matisse
Lithographs

Susan Lambert

UNIVERSE BOOKS
New York

Introduction

'To tell the truth, M. Matisse is an innovator, but he renovates rather than innovates,'[1] wrote Apollinaire in 1909. This statement is particularly true of Matisse's attitude to print-making. He was untouched by the fashion for larger and more brightly coloured prints set by the posters of Chéret and Toulouse-Lautrec. Nor did he contribute to any of the publications centred round the medium of the colour lithograph that sprang up in the nineties.[2] When he first began to make lithographs Matisse was seeing Signac and Cross, two of the greatest exponents of the colour lithograph, regularly, and a year or two earlier his paintings had been influenced by their pointillist doctrine. Yet, in spite of his love for resonant colours, he chose to remain faithful to the nineteenth century tradition of chalk lithographs printed in black in his lithographic work. Pastel shades only creep into some of his book illustrations towards the end of his life. The means by which his lithographs gain their effects are closer to those employed by Delacroix, Chassériau and Fantin-Latour than to those of his friends and contemporaries.

The lithograph has a very special place in Matisse's work. Print-making of any kind did not hold his attention continuously, but his interest in lithography was the most spasmodic. He focused upon this medium at three different periods in his life: in 1906, 1914 and during the 1920s. He was drawn to all the graphic media when he felt in need of a diversion or at tense moments when he found himself unable to concentrate on the more demanding medium of oil paint. But he turned to lithography in particular at those times in his career as a painter when he needed the self-imposed limitation of black and white, and the wealth of gradations in between, to assist in working out a problem. He made more etchings than lithographs, but the latter are, on the whole, more fully realized and played a more important role in the development of Matisse's work.

His first lithograph, a nude drawn early in 1906 (pl. 1), is unique in his work on stone because of its obvious experimental nature. Drawn after the Fauve

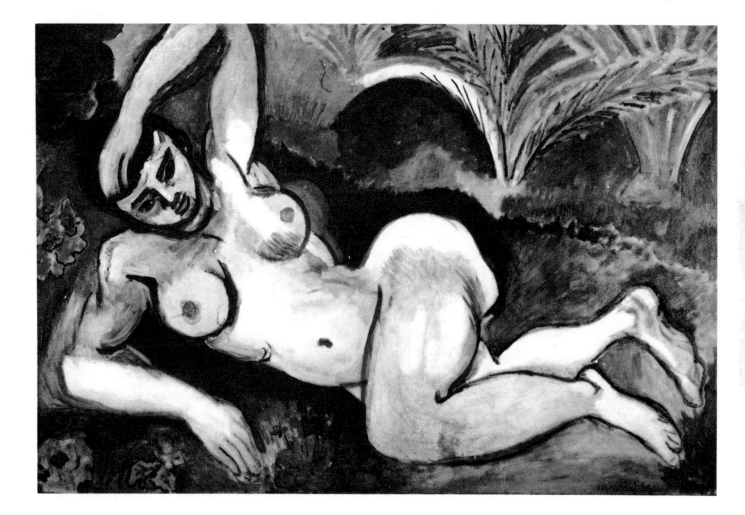

Fig. 1 Le nu bleu. 1907. Oil on canvas.
36¼ × 44⅛ in. Baltimore Museum of Art,
Cone Collection

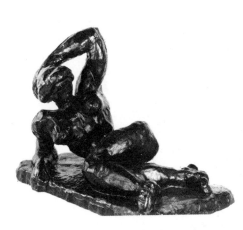

explosion, it reflects Matisse's renewed study of Cézanne and the resulting tightening of the composition, almost before these factors were visible in his paintings. The simplification of the separate parts of the body to their essential and most easily recognizable form results in exciting distortions also found in Picasso's work of that year.[3] This reconsideration of formal qualities – rather than colour – culminated, in Matisse's work, in the large painting entitled *Le nu bleu – souvenir de Biskra* and in the sculpture of the *Nu couché*, both of 1907 (figs. 1, 2).

The rest of the lithographs of 1906, with the exception of a view of the *Port de Collioure*,[4] all have the female head or nude as their subject (figs. 3, 4).[5] The model is shown in a variety of positions, many of them unusual. They are drawn with an energetic line, at times jagged, at times fluid, with the details treated cursorily, calling to mind the mixed style of his Fauve paintings. Not as advanced stylistically as the earlier *Nu*, they reflect the same untamed expressiveness as the Matisse paintings that shocked the French public at the Salon d'Automne of 1905 and gave rise to Matisse's informal election as 'king' of the Fauve painters.

A selection from this series was exhibited, soon after they were drawn, at Matisse's second one-man show held at the Galerie Druet in March 1906. Two years later, accompanied by some water-colours and etchings, they caused a furore in New York at the Alfred Stieglitz Gallery, which was shortly to promote the Dadaists. The American public was more deeply disturbed than the French. The critic of the *New York Evening Mail* wrote that the show included 'some female figures that are of an ugliness that is most appalling and haunting, and that seem to condemn this man's brain to the limbo of artistic degeneration.'[6]

When Matisse, at the age of 22, went to Paris to train as an artist in the winter of 1891–92, he studied for a brief and disillusioning spell under the famous Bouguereau. There he was horrified to find the old virtuoso making a copy of a copy of one of his own paintings,[7] in front of his admirers. In a very different sense Matisse was always trying to paint the same picture. He dreamt of 'an art of balance, of purity and serenity devoid of troubling or depressing subject matter, an art which might be for every mental worker . . . like an appeasing influence, like a mental soother, something like a good armchair in which to rest from physical fatigue.'[8] All his life he strove to

Fig. 3 Tête renversée. 1906. Lithograph. 13¾ × 10¾ in. Collection, Museum of Modern Art, New York, Gift of Abby Aldrich Rockefeller.

create works of art from which this peaceful atmosphere would emanate. Perhaps it was the 1906 series of aggressive lithographs, among other works, that led Matisse to write, 'There was a time when I never left my paintings hanging on the wall because they reminded me of moments of nervous excitement and I did not like to see them again when I was quiet.'[9]

After 1906 Matisse lost interest in all forms of print-making until 1914. Then, unsettled by the declaration of war, he found himself unable to cope with large-scale oil painting, and so for a while he concentrated on a variety of minor media. He made at least sixty etchings and dry-points as well as nine monotypes and nine or ten lithographs. Eight of these lithographs are in the Museum's collection and six of them have been included in this exhibition (pls. 2–7).[10]

Small informal portraits of his friends (fig. 5) were Matisse's favourite subject for the etching needle, but he did not deviate from the study of the female nude in his drawings on stone. As before she is shown from a variety of angles, from the front, back and side, full and half-length, smiling and pensive. Again the artist has chosen the vertical format exclusively, but the lithographs are of a larger scale. Generally they are more imposing. Fitting the figures brilliantly into the confines of the sheet, he lops off their extremities in such a way as to strengthen the impact of the torso (pl. 3). The sinuous arabesques reflect his understanding and lifelong admiration of the master of line, Jean Dominique Ingres. In one case the female form is evoked by as few as four fluent lines (pl. 6). The purity of this form calls to mind Ingres' treatment of the female back in *La Baigneuse de Valpinçon* and *Le Bain Turque*. In another lithograph Matisse allows a void to suggest the mass of a girl's head as well as any lines or shading could (pl. 5). It seems impossible that Bouguereau could have told him, 'You'll never learn to draw.'

In spite of the fraught state of the artist's emotions, these lithographs come nearer to the artist's ideal of tranquillity than the earlier series. Nevertheless, they were drawn at a time when Matisse had moved away from the relaxed decorative style epitomized by the four interiors of 1911.[11] Strange and disturbing elements assert themselves in such paintings as *Femme au tabouret*[12] and in the unusual portraits[13] of Mlle Yvonne Landsberg and Mme Greta Prozor. The lithographs are not devoid of

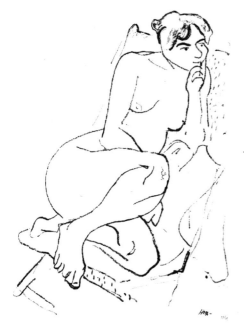

Fig. 4 Nu assis dans une chaise pliante.
1906. Lithograph. $14\frac{3}{4} \times 10\frac{5}{8}$ in. Collection,
Museum of Modern Art, New York, Gift in
memory of Leo and Nina Stein

these. The charm of the *Torse*, '*les yeux noirs*' (pl. 5) and the lithograph of
the same model with her head inclined gently to the left (pl. 7) is tempered
by a feeling of restlessness. There is an uneasiness about the reading figure
(pl. 2) and a strong sense of disquiet in *Nu au rocking-chair* (pl. 4), akin to
contemporary paintings by Kirchner, a leading German expressionist. The
figure in the rocking-chair has a lack of balance rare in Matisse's work, but
highly suitable for the subject. The theme and composition of this lithograph
are similar to Matisse's portrait of his wife[14] painted during more than one
hundred sittings the year before. But, in the case of the lithograph the
model's face is notable for its alive and even manic expression. This is quite
unlike Mme Matisse's vacant gaze, and indeed, the facial expressions that
appear in all Matisse's work after his Fauve period (pls. 16, 17, 18).

'Expression,' wrote Matisse in 1908, 'does not consist of the passion
mirrored upon the human face or betrayed by a violent gesture. The whole
arrangement of my picture is expressive. The place occupied by figures or
objects, the empty spaces around them, the proportions, everything plays a
part. Composition is the art of arranging in a decorative manner the various
elements at the painter's disposal for the expression of his feelings . . . All
that is not useful in the picture is detrimental . . .'[15] In order to achieve
this form of expression, Matisse appears to have deliberately separated the
various elements of composition one from another and to have studied them
in the medium most natural to them.[16]

This approach is most clearly demonstrated in his work between 1905
and 1907, when Matisse studied form, line and colour separately and
simultaneously in three media. Until 1905 his three dimensional output was
limited to three important works and a few minor pieces. During the next
two years he explored the properties of form and surface texture in about a
dozen small sculptures of the female nude, and in several modelled heads.
In the lithographs of 1906 he allowed his chalk to run freely over the stone.
With dots, dashes and sweeps, he studied the power of line to suggest
rhythm, mass and emotion; on the other hand colour was only given free
rein in his wild and brilliant but loosely structured Fauve paintings. The
line is much more condensed and the space around it more important in the
lithographs of 1914. Executed at a time when colour and decorative details
were brought to a minimum in his paintings, Matisse concentrated on paring

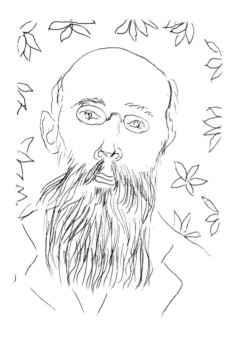

Fig. 5 Portrait de Bourgeat. 1914. Etching. 7⅛ × 3 1/16 in. Collection, Museum of Modern Art, New York, Acquired through the Lillie P. Bliss Bequest

down his line in the lithographs. With a simple curve, a slight alteration of pressure, a gradual thickening of the line, he produces graceful and poetic images in which nothing is superfluous.

That Matisse consciously followed this practice of isolating certain compositional elements is shown by his symbolic arrangement of his work exhibited in the Montross Gallery, New York, in 1915. The exhibition was held in three rooms; the first was devoted to his graphic work, including seventeen lithographs picked from both the early and recent series, and the last to eleven pieces of sculpture. Sandwiched between them was a gallery of canvases. There Matisse's researches into line and form, represented in the rooms on either side, were unified with another element of composition – colour – in his paintings.

Matisse continued to etch intermittently throughout the war, but published no more lithographs until 1922. Then, for the next eight years, he concentrated on this medium, increasing his output towards the end of the decade. The lithographs of 1906 and 1914 have more in common with his drawings than his paintings. During the twenties he widened the scope of the medium. The figures are put into a setting; sometimes they are clothed. Shading is introduced and highlights are scratched in (pls. 17–20). Generally the prints become more substantial and closer to his paintings.

After 1916 Matisse lived for all but the hottest months of the summer in Nice. The paintings of the first half of the 1920s, imbued with the clear light and the relaxed atmosphere of the Mediterranean, are often considered gay and decorative but not very adventurous. They certainly reflect the relief Matisse must have felt with the war over, and were influenced by the enthusiasm with which he was taken up by fashionable society. In 1920, when Matisse was fifty, the first monographs on his work began to appear. The following year the French Government bought one of his paintings for the Luxembourg Museum and in 1925 he was made a Chevalier of the Legion of Honour. Nevertheless, the leisurely mood of these paintings is to some extent deceptive.

More than most artists Matisse needed time for his ideas to crystallize. As he quietly contemplated his model he developed the vocabulary that would evolve into the radical cut-paper gouaches of his last years.[17] The series of

blue seated nudes, and the *Women with Monkeys* grew out of his procession of odalisques. The play on shapes in the cut gouaches of women and amphorae is simultaneously an elaboration and a simplification of his many compositions of women and flower vases (pls. 9, 17, 18, 29, 36). The late floral decorations are a stylization of the rich colourful patterns that bespatter his paintings and prints of this decade. 'There is no break between my paintings and my cut-outs. Only with something more of the abstract and the absolute, I have arrived at a distillation of form,'[18] wrote Matisse, '. . . Cutting coloured papers permits me to draw in colour . . .'[19]

The vibrant quality of Matisse's colour is well known. He always stressed that this effect was achieved by the relationship between the various colours as much as through their individual brilliance. He explained the mental process he went through as he applied colour to his paintings in *Notes d'un peintre:* 'I have before me a cupboard; it gives me a sensation of bright red . . . and I put down a red which satisfies me; immediately a relation is established between this red and the white of the canvas. If I put a green near the red, if I paint a yellow floor, there must still be between this green, this yellow and the white of the canvas a relation that will be satisfactory to me. But these several tones mutually weaken one another. It is necessary therefore, that the various elements that I use be so balanced that they do not destroy one another . . . the relation between tones must be so established that they will sustain one another.'[20] At least half of his student copies were made after the delicate works of eighteenth century French artists like Watteau, Chardin and Fragonard. He also studied the carefully modulated work of Vermeer, de Heem, Van der Heyden and Ruysdael and later said that what he was after then was 'the gradations of tone in the silver scale dear to the Dutch masters, the possibilities of making light sing in muted harmony, by graduating the values as closely as possible.'[21] Eventually he went so far in this quest as to paint a black and white interpretation of Delacroix's richly coloured *Enlèvement de Rebecca.*[22]

The lithographic technique is naturally disposed to the careful analysis of the gradations of tone. It is not, therefore, a coincidence that this medium was of particular interest to the artist during a decade when his canvases again filled the convalescent world with gay and brilliant colour. Finding the black and white equivalents of the surrounding colours, he achieved

with his subtle balance of light and shade that 'living harmony of tones, a harmony not unlike that of a musical composition'[23] that he so desired. Matisse himself stated that his line drawings were 'generators of light' and that 'looked at in a poor or indirect light, it is plain that they contain not only quality and sensibility of line, but also light and differing values corresponding to colour.'[24]

Matisse's first prints after resuming work on the stone were a series of line drawings of the female nude. They are smaller and a little less fluent than the 1914 series. The metaphorical titles of a pair of this group *La Nuit* (pl. 8) and *Le Jour*[25] are unusual in his work,[26] as is the way the figures float unsupported. They echo, loosely, in pose as well as title Michelangelo's female personifications of 'Dawn' and 'Night'. Another lithograph of the following year, showing the same model with the alert expression of *Le Jour*, has a title closer to the figure she most resembles in the Medici Chapel, *Petite Aurore*.[27] In spirit, however, she has moved further away. Unlike those of the earlier pair, the image was drawn directly on the stone, so her pose, when printed, is reversed from her prototype. Now more fully modelled, she reclines in comfort on a couch against one of the decorative backgrounds so typical of Matisse's work in the twenties.

Early in his career Matisse told Apollinaire that he never avoided the influence of others. 'I believe that the personality of the artist develops and asserts itself through the struggles it has to go through when pitted against other personalities. If the fight is fatal and the personality succumbs, it means that that was bound to be its fate.'[28] Matisse shared none of the scorn felt by many of his contemporaries for the Old Masters. Instead of longing, like the Futurists and Dadaists, to burn down the museums, he spent hours studying in the Louvre. More fashionably he extended his willingness to learn from others outside his native Western culture. The influence of the East is felt as much in the lack of linear perspective and the profusion of flat brightly patterned surfaces in his work, as in the actual portrayal of textiles, pots and jewellery collected on his trips to North Africa.

By the 1920s the influence of most individual artists had been thoroughly assimilated into his personal style. It would be fruitless, and indeed impossible, to trace exactly what Matisse owed to whom. Ingres' importance has already been discussed, yet Matisse never owned a painting by him.

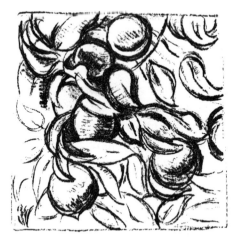

One of his most treasured possessions, bought in 1899 in spite of limited means, was a small canvas of three bathers by Cézanne.[29] The tilted picture plane, the divided background in which still-life merges with wall-paper, and the palpable quality of the atmosphere in such works as *Odalisque au magnolia* (pl. 14) all owe something to Cézanne. Matisse recorded his admiration for this artist by contributing a lithograph (fig. 6) after another painting he owned by the master to a memorial volume brought out by Bernheim-Jeune in 1914.[30] The undulating lines, simultaneously describing a branch of peaches and making an independent pattern against a closed background, anticipate his treatment of the nude in the 'Arabesque' series (pls. 32–4) of 1926 and in the lithographic variations on the theme of the reclining nude, the Louis XIV table and the brass stove of 1929 (pls. 43, 46).

More superficially the influence of artists he saw frequently is evident in specific works. Matisse often visited Renoir and after his death continued to sketch his sculpture in the garden at Cagnes. There is a passive monumentality about some of Matisse's figures, especially the girl wearing *La capeline en paille d'Italie* and the *Nu au turban* (pls. 13, 39) reminiscent of the older master's work. Bonnard, a contemporary of Matisse, also lived along the coast at Antibes. His presence is most apparent in the lithograph *Figure dans un intérieur* of 1925 (pl. 22) and in a number of oils, also depicting tables laden with fruit, painted during the same year. This domestic treatment of the interior, the high viewpoint, the glimpse through to another room, and the portrayal of his model as a home-maker rather than an exotic animal all owe something to his contact with Bonnard.

There is no distinct stylistic progression in the lithographs of the twenties. Matisse continued to draw in line at the same time as producing rich chiaroscuro effects. In an article he wrote on his drawing style, Matisse embraced all the graphic media in which he worked under the general heading of 'dessin.'[31] In this he said that he believed his line drawings, mistaken by some as mere sketches, to be the purest and most direct translation of his emotion. But he stressed the importance of the drawings built up with shading. Finding this a less demanding way of drawing, he was able 'to consider simultaneously, the character of the model, her human expression, the quality of the surrounding light, the atmosphere and all that can be expressed by drawing.'[32] The disparity between contemporary prints is shown

by comparing the highly modelled portrayal of a dancer looking at herself in the glass and the calligraphic rendering of the same subject, both of 1927 (pls. 35, 37).

His attitude to his models, however, altered considerably. They were always carefully chosen local girls and to begin with they remain in Matisse's representations twentieth century girls, even when they are dressed up in the finery of an odalisque (pl. 15). Wearing fresh summer dresses, they are portrayed reading, sleeping, dreaming or sunk in thought (pls. 12, 10, 13, 17). Usually they are posed in the artist's rooms, but occasionally they sit on a balcony or venture right out into the open air (pls. 18, 11). As time passes Matisse indulges his love of the Orient. The atmosphere becomes scented and the setting exotic. He delights in playing off the curves of his model against an austerely striped background (pls. 24, 25, 27) or enveloping her in luxurious drapes; in emphasizing the softness of her body seen through diaphanous layers and in expressing the glint of jewels (pls. 26, 28). His models are transformed into the inhabitants of a harem and the busy promenades of Nice are shut out. The basic subject matter of *Nu couché, fond moucharabi* of 1922 (pl. 10) is similar to that of the *Odalisque, brasero et coupe de fruits* of 1929 (pl. 47), but the atmosphere that pervades them is completely different. The lithe nude of the earlier lithograph emerges fresh and young from the Oriental patterning. She will wake up and go out into the bright sunlight. The voluptuous odalisque of the later print reclines, timeless, as much part of the sumptuous setting as the fancy stove. Even when the Niçoise remains herself, her youthful demeanour is replaced by chic sophistication. The model in *La robe jaune, rubans noirs* (pl. 9) is dressed in a plain fabric and wears no jewels. Her simplicity is echoed by the vase of anemones, with their velvet centres and the ribbons of her frock giving the only·notes of richness. The model for *Le renard blanc* (pl. 48) is finely clothed. Large pearls gleam around her neck, and her satin jacket is edged with silken frills; around her shoulders is thrown the thick white fur that gives the print its title.

After Matisse visited Italy in 1925 his painting became more obviously experimental. Until 1929 this is only reflected in his lithographs in isolated examples. The life-size portrait head of the pianist Alfred Cortot[33] of 1926 (pl. 31) is one of his most striking lithographs because of its treatment as

well as its masculine subject. His face is delineated almost as simply as in the very small dry-point[34] Matisse drew of him at the same time. The only elaboration is the suggestion of the planes of the nose, forehead and skull by shading with the side of the chalk. A more adventurous approach is also detectable in the *Danseuse au miroir* of 1927 (pl. 38), which exhibits a more complicated use of reflections than is found in his work of the early twenties. In *Odalisque, culotte rayé, profile reflété dans la glace* of 1923 (pl. 15) the figure makes sense on her own. The glass is used in the traditional way, to give another view of the model and to play off wittily the curves of her body, especially her breasts, against those of the elegant fireplace. In the later lithograph the mirror is essential to the understanding of the dancer's extraordinary contorted pose.

In January 1929 Matisse himself verbalized a lurking dissatisfaction with his recent sensuous work: 'One may demand from painting an emotion more profound . . . which touches the spirit as well as the senses.'[35] During this year he virtually gave up painting and concentrated on print-making and sculpture.[36] He released a record of well over twenty lithographs, which compensated for the dearth of the previous year, when he apparently published none at all.

Many of the lithographs issued in this transitional year epitomize all that is sensuous in Matisse's work. Some are highly modelled with each luxurious texture brilliantly simulated (pl. 48), while others, preserving the flat picture plane, are covered with a series of decorative arabesques. The contours of the model are as inextricably woven into the general pattern as those of the flamboyant accessories (pls. 43, 45, 46).[37] But a number reflect the new feeling for structure and the movement towards less seductive surfaces visible in his latest paintings. The puritan surface of the linear *Figure voilée aux deux bracelets* (pl. 44) relates it to his dry surfaced paintings of the late twenties and early thirties, and, on account of its mysterious subject, to *Femme à la voilette*[38] in particular. Midway between these extremes of luxury and economy lie lithographs like *Figure endormie, châle sur les jambes* and *Figure endormie (sol aux carreaux rouges)* (pls. 41, 42). With less evocative titles they show in comparison with *Odalisque, brasero et coupe de fruits* (pl. 47) a new restraint in their composition. The model, caressed by the filtering light, reclines against a regular squared-off background

instead of an energetic ogee motif, and the profusion of accessories has vanished. The lithograph *Nu assis, bras gauche sur la tête* (pl. 40), also of 1929, reflects Matisse's increased interest in sculpture in the solid and compact pose of the model. The distortions of the figure, with one leg elongated and the other compressed, are also reminiscent of the figure in the bold *Figure décoratif sur fond ornemental*[39] painted in 1927.

In 1930 Matisse's routine was disrupted. He made the long journey across the Atlantic several times, visiting the United States and Tahiti, which left him very little time for creative work. The pattern of his life changed and the yearly production of a series of lithographs came to an end. There are only two lithographs, *Persane* and *Figure dans fauteuil*[40] (pls. 49, 50), from this year in the Museum's collection. They are unusual in the way they combine two distinct drawing methods, the light feathery style of *Nu au turban* (pl. 39) and the distinct sharp-edged line of the 'Arabesque' series (pls. 32–4).

Book illustration, or as Matisse liked to think of it 'book decoration,' became the graphic field that held his interest. Some of the books were 'decorated' with lithographs[41] but after 1930 he seldom drew lithographs independent of the printed word. In his books the texts have much the same relationship with their ornamented backgrounds as the models have with their richly patterned surroundings.

Many of Matisse's lithographs look, at first sight, as if they are black and white copies, usually scaled down, of his paintings.[42] Yet Matisse believed that composition 'alters itself according to the surface to be covered.' The shape and size of the surface are an integral part of the design. 'An artist who wants to transpose a composition on to a larger canvas must conceive it over again in order to preserve its expression; he must alter its character and not just fill in the squares into which he has divided the canvas.'[43] In fact by tightening or loosening the design, lowering or lifting a limb and re-distributing the patterned surfaces, Matisse masterfully altered the composition to fit the different media and formats. Normally he worked on related compositions in different materials concurrently. The lithographs were parallel developments to his paintings rather than preliminary studies for them or copies after them.

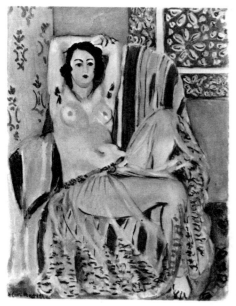

Fig. 7 Odalisque à la jupe de tulle. 1923.
Oil on canvas. 25⅝ × 19¾ in. National
Gallery of Art, Washington, D.C., Chester
Dale Collection

The lithograph of the *Odalisque à la jupe de tulle* (pl. 19) has the same composition as the painting with that title (fig. 7), except for subtle but important differences.[44] It is, however, the distribution of the colour, the element which is absent from the lithograph, rather than the relationship of the forms, that plays the most important part in holding the painting together. The red of one of the wall-hangings in the background is the same as that of the carpet in the foreground and reappears in dabs on the model's mouth and nipples. The plain ochre of the wall is echoed by the green and ochre drape over the chair and by the ochre pattern on the odalisque's tulle skirt. The composition of the lithograph is much more compact. The bulbous curves of the armchair and the tulle skirt form a single amoeba-like shape which is shown off against one rectangular wall-hanging. The composition is further unified by the overall patterning, the small design on the chair showing through the tulle skirt and mingling with its embroidered motif.

At regular intervals during his life Matisse became obsessed by certain compositional problems. The search for the solution would then dominate his work in all media, just as the pose of the model with her arms above her head did during the twenties. In the painting and lithograph of the *Odalisque debout et plateau de fruits* (pl. 20) the uncluttered lines of her body are played off against the design of a Persian hanging. In a later lithograph *Torse à l'aiguière* (pl. 36) he amusingly illustrates his words of some years earlier: 'The pelvis fits into the thighs and suggests an amphora.'[45] Hiding the model's legs under a shawl, he emphasizes the similarity in shape between the torso and the amphora. The pattern on the wall echoes the rhythm they set up.

Another pose that fascinated him was that of the seated model with one leg raised and tucked under the other. Trying the model with her arms above her head and by her side, facing left and right, shifting the position of her legs, and twisting the body, Matisse developed this pose until he arrived at a solution that satisfied him in several media. The series reached its climax in bronze in the *Grand nu assis* completed in 1925 (fig. 8) and in oil in the *Nu au coussin bleu* of 1924.

Solely on the basis of composition the lithograph that shares the title *Nu au coussin bleu* (pl. 21) is nearest to this painting. But another lithograph,

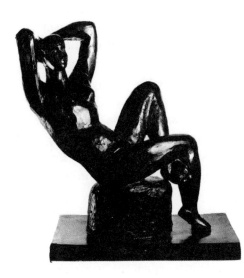

Fig. 8 Grand nu assis. 1925. Bronze. Height 30¾ in. The Minneapolis Institute of Arts, Gift of the Dayton-Hudson Foundation

La culotte bayadère (pl. 23), is nearer its counterpart in stature. In the painting the pale flesh of the model's hips and belly is offset against the intense blue of the cushion, forming the focal point of the composition. The monochrome lithograph, lacking such a point of interest (Matisse did not even draw in the cushion that gives the print its name), appears in comparison unexciting. In a slightly later lithograph[46] of the same subject, Matisse draped a floral fabric over the chair and introduced the fireplace to the right, creating a lively interplay between the curves of the woman's body, the patterned material, the armchair and the fireplace. The fabric remains in *La culotte bayadère*, but the armchair, placed frontally, fills up the space, eliminating the fireplace. The model no longer holds her arms above her head and her pose is generally more relaxed. A focal point is provided by the shimmering vortex of her striped satin pantaloons.

At other times Matisse became absorbed in a specific subject. The lithographs of 1927 were almost exclusively devoted to the ballerina.[47] It is not clear what prompted Matisse's sudden interest in the dancer, which also manifested itself in four oil paintings and four pastels. He had designed the costumes and scenery for Diaghilev's production of the ballet *Le Chant du Rossignol* in 1920, from which his warm friendship with the choreographer, Massine, dated. But unlike many of his fellow artists, he was not particularly interested in designing for the stage and did not collaborate on another ballet for eighteen years. It may be significant, however, that *Le Chant du Rossignol* was revived[48] the same year that Matisse developed his interest in portraying dancers.

Matisse presents his ballerina sitting and lying down, or standing relaxed at the *barre*, but never actually dancing. Indeed his models are seldom shown in motion or doing anything more energetic than reading a book. In *Notes d'un peintre* he stated that movement being inherently unstable was not suited to be represented in a durable form. That 'abandoning the literal representation,' that is exaggeratedly bulging muscles, or the snap-shot image, 'it is possible to reach towards a higher ideal of beauty.' He cites the work of Egyptian and Greek artists to support his argument. An Egyptian statue looks rigid 'yet we feel in it the image of a body capable of movement and which despite its stiffness is animated.' A Greek will either represent a man hurling a discus by showing him at the moment he

gathers his strength, or else, if the action is shown at its most violent, he will condense a succession of movements to re-establish the balance, and to give the work a feeling of duration.[49] Matisse suggests the movement of his ballerina by showing her in moments of repose between movement. In *Danseuse reflet dans la glace* (pl. 35) she rests arching her aching back, studying her reflection in the glass. Her *tutu* flutters from past movement and her feet are poised about to take off again. The pert *Danseuse debout, visage coupé* (pl. 37) lolls against an invisible support, yet somehow the fluid line that describes her figure suggests the tension she has undergone just as strangely as rigid Egyptian statues appear active.

'What interests me most is neither still life nor landscape but the human figure,'[50] wrote Matisse. This preference is particularly noticeable in the subject matter of his lithographs, where the single female figure is almost his only theme. Only two lithographs[51] in the Museum's collection were composed with more than one figure, and in each of these he used the same model put into different poses. In spite of the formal relationship between the figures, there is no emotional communication. Matisse explained his attitude to his model in the article on his drawing: 'They are the principal theme in my work. I depend entirely on my model whom I observe at liberty, and then I decide on the pose which best suits her nature. When I take a new model, it is in complete relaxation that I can see the pose that will best suit her, and to which I am then completely committed. I often keep these girls on for several years, until I lose interest Their forms are not always perfect, but they are always expressive. The emotional interest they inspire in me is not especially apparent in the representation of their bodies, but rather in the lines or particular values distributed over the whole canvas or paper, thus forming their orchestration, their architecture.'[52]

In some of the lithographs Matisse concentrates on the faces of his models. Neither the identity of his sitters, their exact features nor their superficial charm were of importance to him. A girl called Henriette was his favourite model during the twenties, but little is known about her.[53] Nor is it always possible to be sure for which prints she posed. With each model he aimed at 'picking out among the lines of her face those which suggest the deep gravity which persists in every human being.'[54] Stripped of all surface prettiness the *Tête de jeune fille au col organdi* (pl. 16) has an icon-like

Fig. 9 Tête de face. 1948. Aquatint.
12⅜ × 9⅞ in. Collection, Museum of Modern
Art, New York, Curt Valentin Bequest

directness that links it with the stark aquatint heads drawn in the late forties (fig. 9) and his last great project, the simple decorations to the chapel at Vence.

Although Matisse worked at a time when many artists were experimenting with abstraction and when some had given up figurative art altogether, all his lithographs were made in the presence of the model.[55] Yet he was impatient with the distinction that is often made between the artist who draws from nature and those who work purely from their imagination. He claimed that the same man often used both methods at different times. Sometimes contact with tangible objects provided inspiration and at other times it supplied the discipline required to organize the artist's sensations into a picture.[56] The relationship between Matisse's art and nature emerges from his description of what happened when he drew a tree: 'It is not a matter of drawing a tree I see. I have an object in front of me which produces an effect on my mind, not only as a tree, but in relation to all sorts of other feelings. I shan't get rid of my emotion by exactly copying the tree.'[57] Matisse used his models, clothed in garments of his own choice, set in an interior he had created, as a vehicle for self-expression. For it was, as he said, through the human figure that he best succeeded in expressing the nearly religious feeling that he had towards life.[58]

Notes

[1] G. Apollinaire, 'Médaillon: un fauve'. Quoted from A. H. Barr, *Matisse, his art and his public*, Museum of Modern Art, New York, 1951, p. 553.

[2] *La Revue Blanche, Les Peintres Lithographies, L'Estampe et L'Affiche*.

[3] Compare Picasso's 'Two Nudes', 1906, reproduced in A. H. Barr, *Picasso, fifty years of his art*, Museum of Modern Art, New York, 1946, p. 52. Picasso and Matisse first met one another late in 1906.

[4] The print in the collection of the Museum of Modern Art, New York, reproduced in W. S. Lieberman, *Matisse, 50 years of his graphic art*, London, 1957, p. 84, may be a unique pull.

[5] According to A. H. Barr, *Matisse, op. cit.*, p. 534, note 7 to p. 99, Matisse may have drawn on as many as 19 stones in 1906, although he has only seen impressions of 10 of them. They were all issued in an edition of 25. Unfortunately none of them is in the Museum's collection.

[6] Quoted from A. H. Barr, *Matisse, op. cit.*, p. 113.

[7] *Le guêpier*.

[8] H. Matisse, *Notes d'un peintre*, originally published in *La Grande Revue*, Paris, 25 December 1908. Quoted from the translation in the catalogue of 'Henri-Matisse Retrospective Exhibition', held at the Museum of Modern Art, New York, 1931, p. 35.

[9] *Ibid*, p. 31.

[10] *Torse sans tête*, E.360–1935, and *Visage ovale*, E.362–1935, are not included in this publication.

[11] *Nature morte aux aubergines, L'atelier du peintre, La Famille du peintre, L'Atelier rouge*.

[12] Painted in the winter of 1913–14. Reproduced in A. H. Barr, *Matisse, op. cit.*, p. 393.

[13] Both painted in 1914. Reproduced in *ibid.*, pp. 395, 405.

[14] Reproduced in *ibid.*, p. 392.

[15] H. Matisse, *Notes d'un peintre, op. cit.*, p. 30.

[16] I owe this idea to Mr Alan Bowness, Reader in the History of Art at the Courtauld Institute of Art, which he expressed in a lecture he gave on Matisse there.

[17] M. Wheeler, *The last works of Henri Matisse, large cut gouaches*, published in connection with an exhibition held at the Museum of Modern Art, New York, the Art Institute of Chicago and the San Francisco Museum of Art, 1961–62, reproduces a good selection of these.

[18] M. Lux, 'Témoinages: Henri Matisse' in *XXe Siècle*, no. 2, 1952. Quoted from M. Wheeler, *op. cit.*, p. 10.

[19] A. Lejard, 'Propos de Henri Matisse' in *Amis de l'Art*, n.s., no. 2, October 1951. Quoted from *ibid.*, p. 10.

[20] H. Matisse, *Notes d'un peintre, op. cit.*, pp. 32–3.

[21] Quoted from R. Escholier, *Matisse from the life*, London, 1960, p. 31.

[22] *Ibid*, p. 31.

[23] H. Matisse, *Notes d'un peintre, op. cit.*, p. 33.

[24] Translated from H. Matisse, 'Notes d'un peintre sur son dessin' in *Le Point*, vol. xxi, July 1939, p. 10.

[25] Reproduced in *ibid.*, p. 8.

[26] Normally Matisse gave his works straightforward titles describing either their mood or subject matter.

[27] Museum no. E.299–1935. Not included in the exhibition.

28 G. Apollinaire, 'Matisse', originally published in *La Phalange*, vol. 2, no. 18, 15 December 1907. Quoted from the translation in A. H. Barr, *Matisse, op. cit.*, p. 101.

29 Reproduced in A. H. Barr, *Matisse, op. cit.*, p. 18.

30 O. Mirbeau, *Cézanne*, Paris, 1914, pl. v. Cézanne's painting is reproduced in L. Venturi, *Cézanne, son art – son œuvre*, Paris, 1936, no. 613.

31 H. Matisse, 'Notes d'un peintre sur son dessin', *op. cit.*, pp. 8–14.

32 *Ibid.*, p. 10.

33 Closely related to this famous portrait is another little known lithographic portrait of Cortot, which exhibits the same boldness although Matisse's line is slightly hesitant. It is reproduced in Sotheby & Co., *Catalogue of modern French and German illustrated books & modern lithographs, etchings and woodcuts*, 12 May 1964, p. 63, no. 227.

34 Measurements $5\frac{3}{8} \times 3\frac{3}{16}$ inches. Reproduced in J. Leymarie, H. Read, W. S. Lieberman, *Henri Matisse*, Berkeley and Los Angeles, 1966, p. 166, no. 288.

35 H. Matisse. Interview with *L'Intransigeant*, 29 January 1929. Quoted from *Formes*, vol. 1, no. 1, January 1930.

36 From 1900 to 1912 Matisse produced over thirty sculptures. Then, except for a few minor pieces and a head of his daughter, he gave up working in this medium until 1925. The *Grand nu assis* inaugurated a new interest in sculpture which culminated in the production of about half a dozen works in 1929. Like lithography, Matisse appears to have lost interest in this medium after 1930.

37 Over half of the lithographs of 1929 have the reclining nude, brass stove and Louis XIV table as their subject. It also occurs in many of his paintings between 1926 and 1928, but none of the lithographs is directly related to a painting.

38 Painted in 1927. Reproduced in A. H. Barr, *Matisse, op. cit.*, p. 446.

39 Reproduced in *ibid.*, p. 449.

40 See catalogue entry for pl. 50.

41 P. Reverdy, *Visages*, Paris, 1946; A. Rouveyre, *Repli*, Paris, 1947; M. Alcaforado, *Les lettres portugaises*, Paris, 1946; *Florilège des amours de Ronsard*, Paris, 1948; *Poèmes de Charles d'Orléans*, Paris, 1950.

42 At least nine of the lithographs in the exhibition are directly related to his paintings of the twenties.

43 H. Matisse, *Notes d'un peintre, op. cit.*, p. 30.

44 See catalogue entry for pl. 19.

45 S. Stein, 'Matisse speaks to his students, 1908'. Quoted from A. H. Barr, *Matisse, op. cit.*, p. 550.

46 *Nu assis au fauteuil*, Museum no. E.365–1935. Reproduced in W. S. Lieberman, *op. cit.*, p. 109.

47 None of the dancer subjects in the Museum's collection is part of Matisse's *Album de danseuses*. Also produced in 1927, it consisted of 10 lithographs with an introduction by Waldemar Georges. It was published in the series 'Galerie Contemporaine' by Alvares.

48 With different choreography but still using Matisse's designs.

49 H. Matisse, *Notes d'un peintre, op. cit.*, pp. 31–2.

50 *Ibid.*, p. 34.

51 *Persane* (pl. 49) and a lithograph of three odalisques, Museum no. E.342–1935, which is not included in the exhibition.

52 H. Matisse, 'Notes d'un peintre sur son dessin', *op. cit.*, p. 13.

53 According to L. Aragon, *Henri Matisse, roman*, vol. 2, Paris, 1971, p. 109, Henriette was Matisse's principal model from 1919 to 1927, but her features seem to appear in later prints, e.g. pl. 48. She was probably the model for the following: pls. 13–21, 23–5, 27, 28, 32, 34–6.

54 H. Matisse, *Notes d'un peintre, op. cit.*, p. 34.

55 Whether drawn directly on the stone or on transfer paper.

56 H. Matisse, *Notes d'un peintre, op. cit.*, p. 35.

57 L. Aragon, *Henri Matisse (Matisse-en-France, dessins. Thèmes et variations)*, Paris, 1943. Quoted from R. Escholier, *op. cit.*, p. 122.

58 H. Matisse, *Notes d'un peintre, op. cit.*, p. 34.

Select Bibliography

A. H. Barr, *Matisse, his art and his public*, Museum of Modern Art, New York, 1951.

Berggruen & Cie, *Henri Matisse lithographies rares*, introduction by Marguerite Duthuit, Paris, 1954.

Bibliothèque Nationale, *Matisse, l'oeuvre gravé*, Paris, 1970.

R. Escholier, *Matisse from the life*, London, 1960.

J. Leymarie, H. Read, W. S. Lieberman, *Henri Matisse*, Berkeley and Los Angeles, 1966.

W. S. Lieberman, *Matisse, 50 years of his graphic art*, London, 1957.

H. Matisse, 'Notes d'un peintre sur son dessin' in *Le Point*, vol. xxi, July 1939, pp. 8–14.

Museum of Modern Art, *Henri Matisse retrospective exhibition*, New York, 1931. Includes an English translation of *Notes d'un peintre*.

C. Roger-Marx, 'The engraved work of Henri Matisse' in *Print Collectors Quarterly* vol. xx, no. 2, 1933, pp. 138–57.

Catalogue

Matisse usually drew the more densely modelled subjects directly on the lithographic stone, sometimes taking many sessions, spread over several years, before the print reached its final state (pl. 48). The line images were more often drawn on paper and transferred on to the surface of the stone. Using this method the artist does not have to cope with the cumbersome stones himself or allow for the reversal of the drawn image. Thus, a *lithograph* is printed in reverse from the drawn image, whereas a *transfer lithograph* is printed in the same sense as the artist drew it.

The lithographs of 1906 and 1914 were printed by M. Auguste Clot and those of the twenties by M. Duchâtel. Matisse's later lithographic work, not included in this publication, was printed by M. Mourlot. The printing was always done either under the supervision of Matisse or of his daughter. The lithographs are printed on four different types of paper: chine, japon, and Arches of two colours. The editions, seldom larger than 75, were published by the artist.

The titles and dates given here have been provided by Madame Duthuit. The titles are those assigned by the artist either when they were drawn or when they were put on sale. The dates refer to the year the lithographs were drawn, or in cases when work on them was spread over a long period, to the year of completion.

The 'D' numbers refer to their place in the complete catalogue of Matisse's graphic work, being compiled by his family. Most of the prints have this catalogue raisonné number pencilled on the back. They were allotted in order of printing, which usually, but not always, corresponds to the order in which the lithographs were drawn.

The measurements refer to the size of the drawn image. They are given in inches, followed by centimetres in brackets, with height preceding width.
Each print has been stamped on the back once, and in some cases twice, by the French customs authorities.

Nu. 1906. D. 10 or 29

Signed in pencil *Henri-Matisse*. Numbered
30/50
Lithograph on chine. 11 × 10 (27·9 × 25·4)
E.281–1935

Woodcut of a nude in the same pose entitled
Nu, le grand bois, 1906. Reproduced with
the wood block in J. Leymarie, H. Read,
W. S. Lieberman, *Henri Matisse*, Berkeley
and Los Angeles, 1966, pp. 162–63,
pls. 234–35

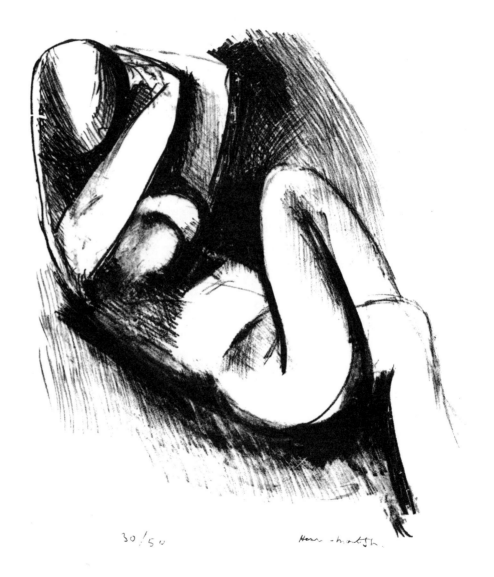

2 Nu de profil, figure lisant. 1914. D. 14

Signed on the stone *HM*. Signed in ink
Henri Matisse and inscribed *ép-d'etat*.
Inscribed in pencil on the back *Liseuse profil*
Published in an edition of 50
Transfer lithograph on japon impérial.
$19\frac{5}{8} \times 10$ (49·8 × 25·4)
E.364–1935

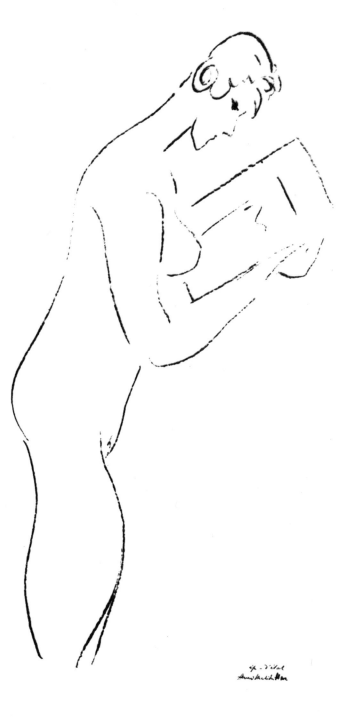

3 Nu au visage coupé. 1914. D. 15

Signed on the stone *HM*. Inscribed in pencil
on the back *torse 3/4*
Trial proof. Not part of the edition of 50
Transfer lithograph on japon impérial.
19¾ × 12 (50·3 × 30·5)
E.363–1935

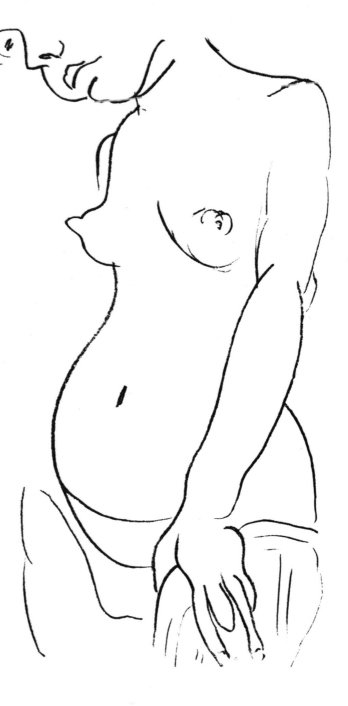

4 Nu au rocking-chair. 1914. D. 17

Signed on the stone *HM*. Signed in ink
Henri-Matisse and inscribed *épr. d'état*.
Inscribed in pencil on the back *Rocking*
Published in an edition of 50
Transfer lithograph on japon impérial.
$19\frac{5}{8} \times 10\frac{7}{8}$ (49·9 × 27·6)
E.1224–1935

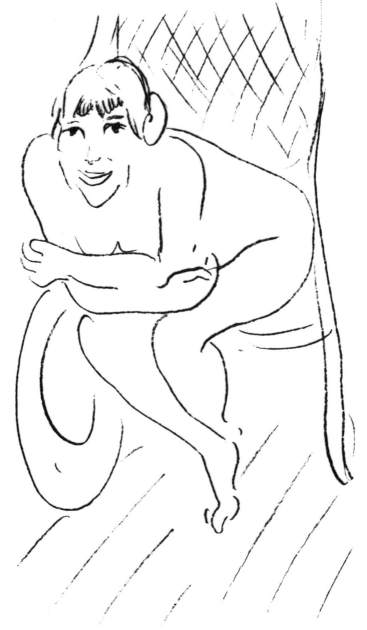

5 Torse, 'les yeux noirs'. 1914. D. 18

Signed on the stone *HM*. Inscribed in
pencil on the back *Yeux noirs*
Trial proof. Not part of the edition of 50
Transfer lithograph on japon impérial.
$17\frac{3}{4} \times 12\frac{7}{8}$ (45·1 × 32·6)
E.361–1935

6 Nu assis de dos. 1914. D. 19

Signed on the stone *HM*. Inscribed in
pencil on the back *dos*
Trial proof. Not part of the edition of 50
Transfer lithograph on japon impérial.
$16\frac{1}{2} \times 10\frac{1}{2}$ (42 × 26·8)
E.359–1935

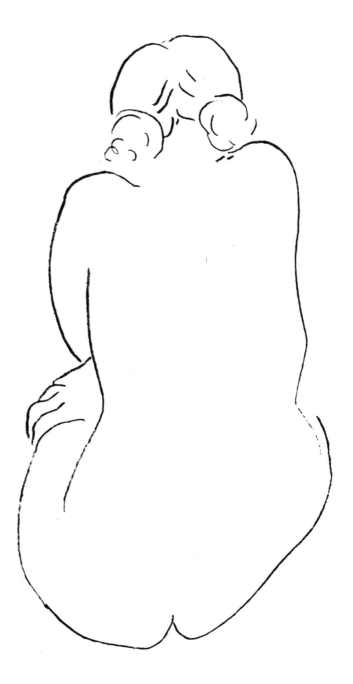

7 Tête penchée vers la gauche. 1914. D.21

Signed on the stone *HM*. Signed in ink
Henri-Matisse and inscribed *épreuve d'état*.
Inscribed in pencil on the back *torse* (deleted)
and *buste*
Published in an edition of 50
Transfer lithograph on japon impérial.
19⅜ × 12¾ (49·2 × 32·4)
E.358–1935

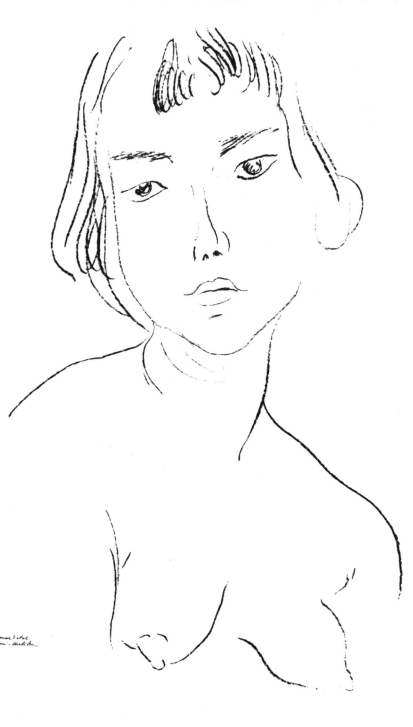

8 La Nuit. 1922. D. 32

Signed in ink *Henri-Matisse*. Numbered
2/50
Transfer lithograph on japon impérial.
$9\frac{7}{8} \times 11\frac{1}{2}$ (25·2 × 29·2)
E.284–1935

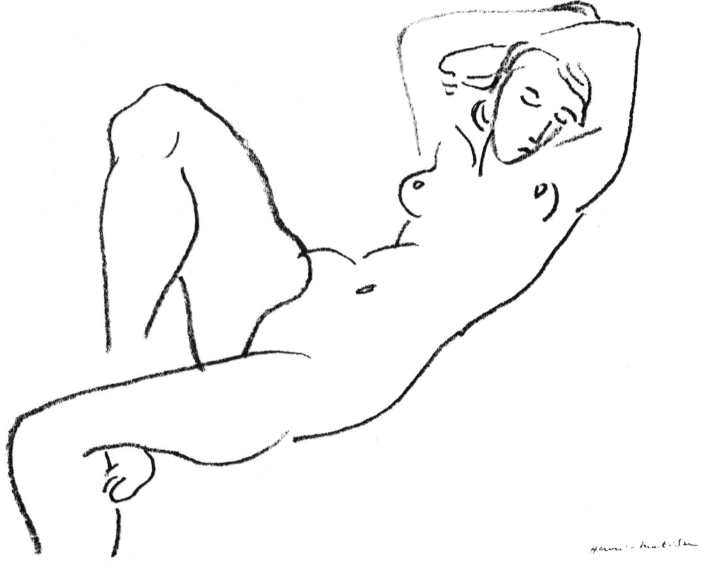

9 La robe jaune, rubans noirs. 1922. D. 34

Signed in ink *Henri-Matisse*. Numbered
2/50
Lithograph on chine. $15\frac{1}{2} \times 11\frac{1}{4}$ ($39\cdot4 \times 28\cdot5$)
E.286–1935
A related oil painting, 1921–22, is in the
Indianapolis Museum of Art, Indiana. It is
reproduced in their *Catalogue of European
paintings*, 1970

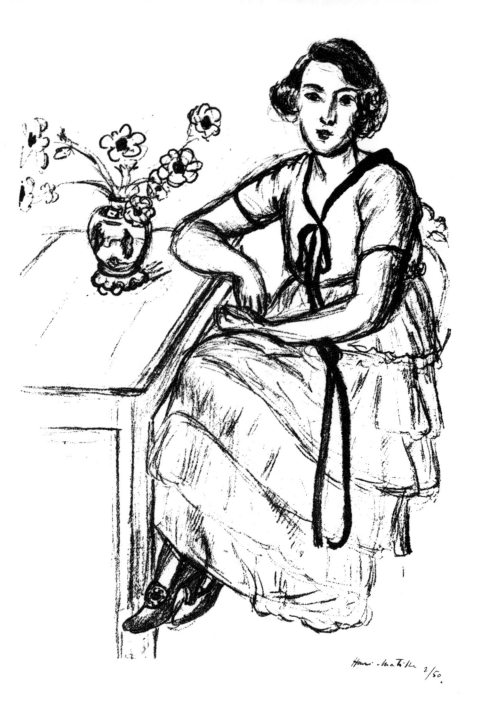

10 Nu couché, fond moucharabi. 1922.
D. 35

Signed in ink *Henri-Matisse*. Numbered
2/50
Transfer lithograph on chine. $17\frac{1}{2} \times 16$
(44·5 × 40·6)
E.287–1935

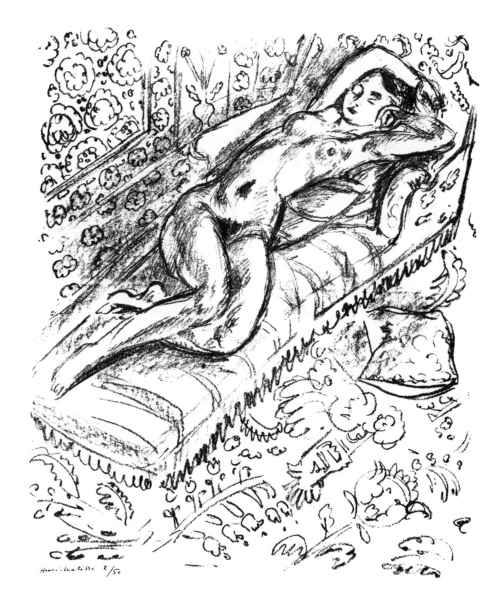

11 Figure à la chaise-longue dans paysage. 1922. D. 36

Signed in ink *Henri-Matisse*. Numbered *2/50*
Transfer lithograph on chine. 16¼ × 20¼ (41·2 × 51·5)

E.288–1935
Oil painting of the same subject entitled *Repos dans un parc*, 1923, in a private collection. Reproduced in R. Huyghe, 'Matisse and colour' in *Formes*, no. 1, January 1930, fig. 7

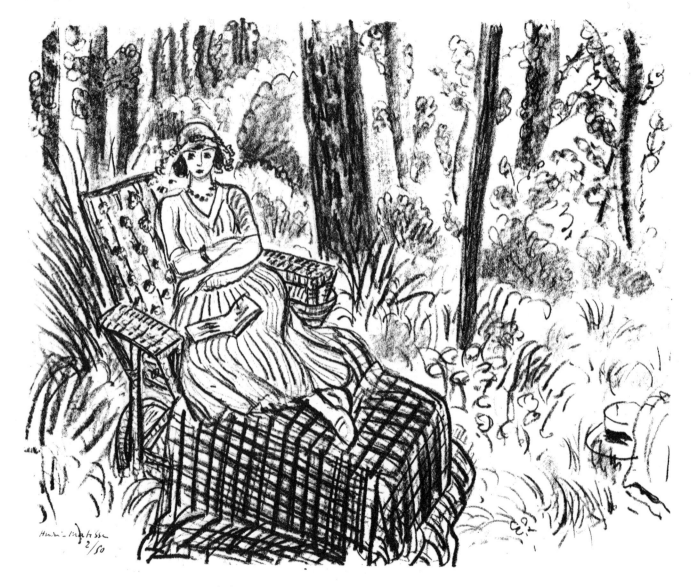

12 Petite liseuse. 1923. D. 40

Signed in reverse on the stone *Henri-Matisse*. Signed in pencil *Henri-Matisse*.
Numbered *2/50*
Lithograph on japon impérial. $11\frac{1}{8} \times 8\frac{7}{8}$
$(28\cdot3 \times 22\cdot5)$
E.1228–1935

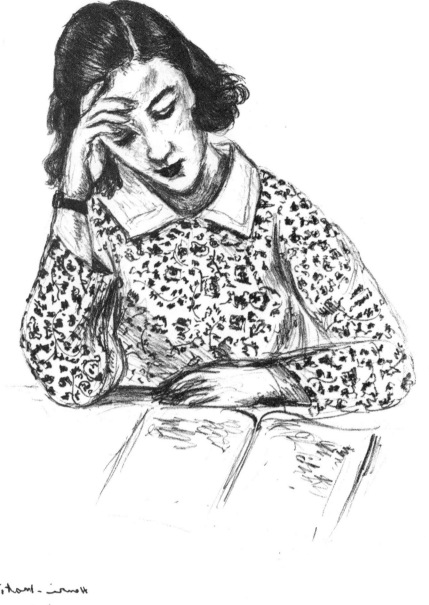

13 La capeline en paille d'Italie. 1923.
D. 41

Signed in pencil *Henri-Matisse*. Numbered
2/50
Transfer lithograph on chine. $17\frac{3}{4} \times 15\frac{3}{4}$
$(45\cdot2\times40)$
E.293–1935

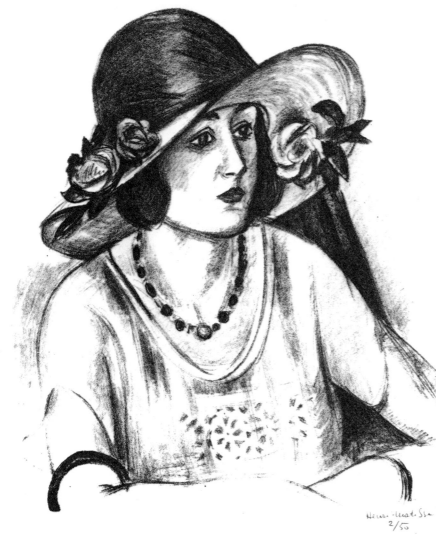

14 Odalisque au magnolia. 1923. D. 42

Signed in pencil *Henri-Matisse*. Numbered
2/50
Lithograph on japon impérial. $11\frac{5}{8} \times 15\frac{7}{8}$
$(29 \cdot 5 \times 40 \cdot 4)$
E.294–1935

Oil painting of the same subject but with
the composition in reverse, 1924, in a
private collection. Reproduced in colour in
Verve, no. 3, October–December 1938,
pp. 78–9 and L. Gowing, *Henri-Matisse,
64 paintings*, Museum of Modern Art, New
York, 1966, p. 48

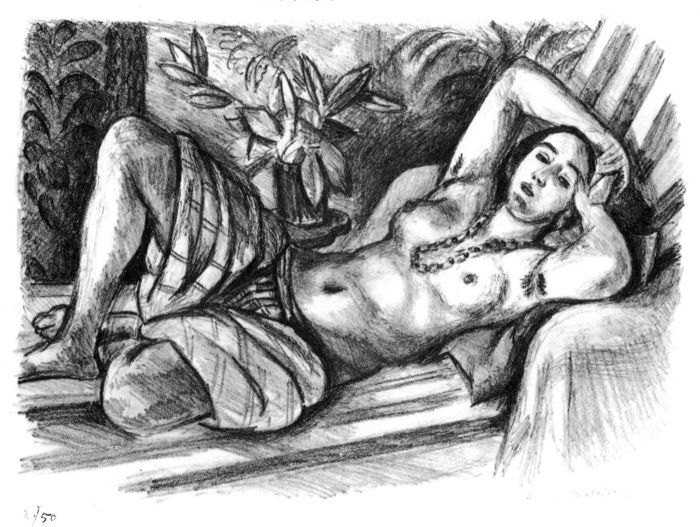

2/50

15 Odalisque, culotte rayée, profil
reflété dans la glace. 1923. D. 43

Signed in pencil *Henri-Matisse*. Numbered
2/50
Lithograph on chine. 15⅝ × 11⅞ (39·6 × 30·1)
E.295–1935
Oil painting of the same subject, but with
the composition in reverse, in the Baltimore
Museum of Art (Cone collection). Repro-
duced in M. Luzi, *L'opera di Matisse, dalla
rivolta 'fauve' all'intimismo 1904–28*, Milan,
1971, no. 406

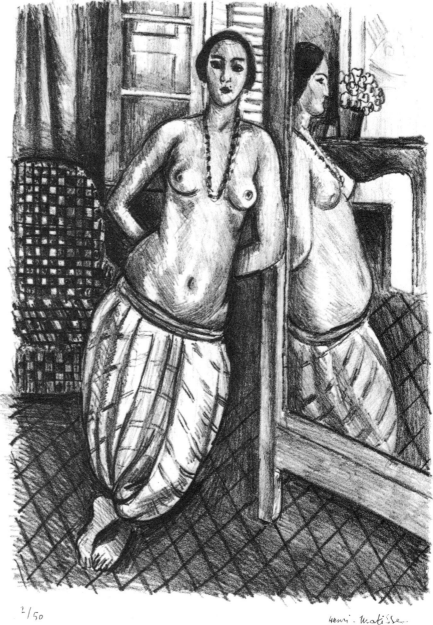

16 Tête de jeune fille au col organdi.
1923. D. 45

Signed in pencil *Henri-Matisse*. Numbered
2/50
Lithograph on chine. $8 \times 5\frac{7}{8}$ (20·3 × 15)
E.296–1935

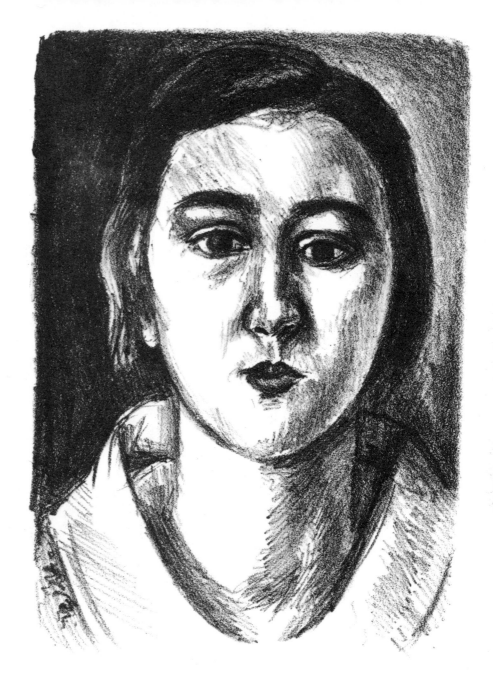

2/50 Henri Matisse

17 Figure accoudée devant paravent
fleuri. 1923. D. 50

Signed in pencil *Henri-Matisse*. Numbered
2/60

Lithograph on chine. 7¼ × 10¼ (18·4 × 26)

E.301–1935

The last 10 numbers of the edition were
allocated to artist's proofs

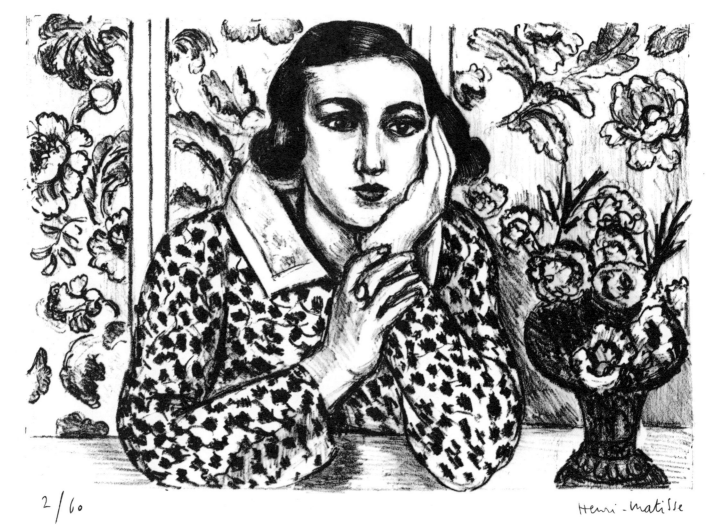

2/60 Henri-Matisse

18 Figure assise, bouquet de fleurs
devant la mer. 1923. D. 51

Signed in pencil *Henri-Matisse*. Numbered
2/60

Lithograph on japon impérial. $10\frac{3}{4} \times 7\frac{1}{2}$
$(27 \cdot 3 \times 19)$

E.302·-1935

The last 10 numbers of the edition were
allocated to artist's proofs

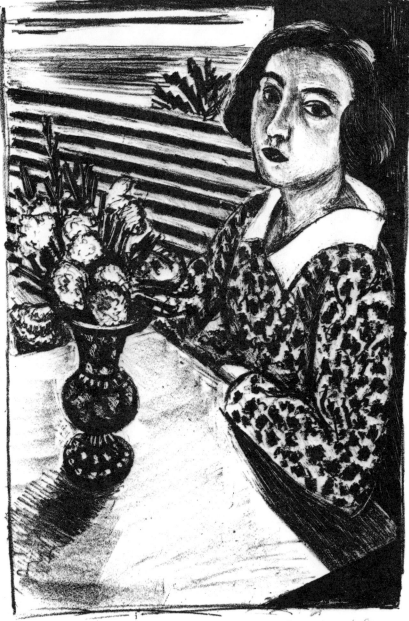

19 Odalisque à la jupe de tulle. 1924.
D. 52

Signed in pencil *Henri-Matisse*. Inscribed on
the front and the back *jupe tulle*.
Numbered *2/50*
Lithograph on chine. 14⅜ × 10⅜ (36·5 × 26·4)
E.1226–1935
Oil painting of the same subject but with the
composition in reverse, 1923, in the National
Gallery of Art, Washington (Chester Dale
Collection). Fig. 7. Reproduced in colour in
L. Aragon, *Henri-Matisse, roman*, vol. 2,
Paris, 1971, p. 92, pl. xi

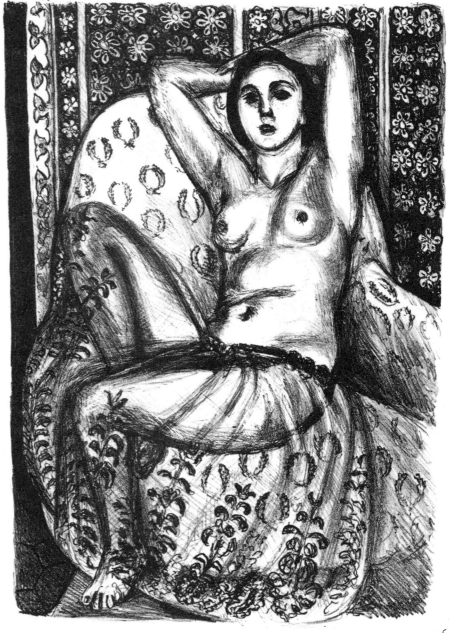

2/50 Henri Matisse

20 Odalisque debout et plateau de fruits. 1924. D. 53

Signed in pencil *Henri-Matisse*. Numbered *2/50*. Inscribed on the back *Figure et fruits* Lithograph on japon impérial. $14\frac{3}{4} \times 10\frac{7}{8}$ (37·5 × 27·6)
E.1225–1935
Oil painting of the same subject, but with the composition in reverse and the odalisque's arms by her side, entitled *Odalisque debout près de la fenêtre*. Present whereabouts unknown. Reproduced in M. Luzi, *L'opera di Matisse, dalla rivolta 'fauve' all'intimismo 1904–28*, Milan, 1971, no. 435.

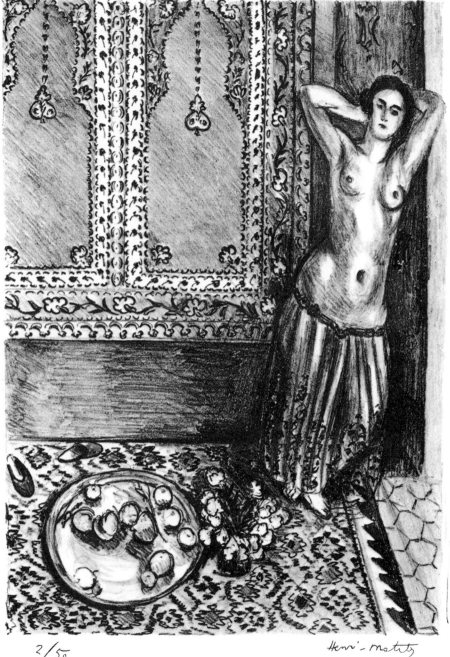

2/50 Henri-matits

21 Nu au coussin bleu. 1924. D. 55

Signed in pencil *Henri-Matisse*. Numbered
2/50
Transferred water-mark *Canson &*
Montgol[fier]
Transfer lithograph on Arches. $24\frac{1}{4} \times 18\frac{7}{8}$
$(61 \cdot 6 \times 48)$
E.303–1935
Oil painting of the same subject, 1924, in
the collection of Mr and Mrs Sidney F.
Brody, Los Angeles. Reproduced in colour
in J. Leymarie, H. Read, W. S. Lieberman,
Henri-Matisse, Berkeley and Los Angeles,
1966, p. 91, pl. 63

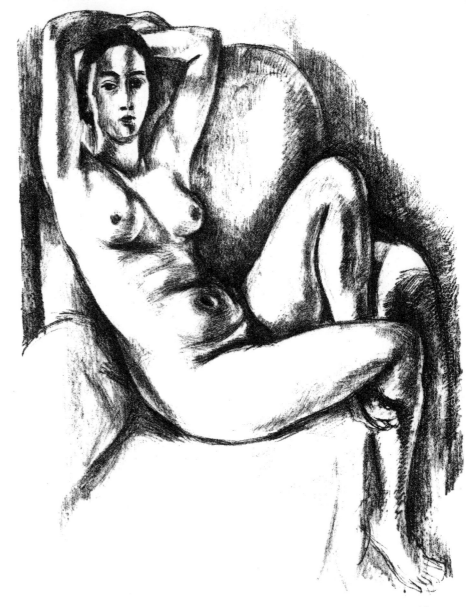

22 Figure dans un intérieur. 1925. D. 60

Signed in pencil *Henri-Matisse*. Numbered
2/50
Transfer lithograph on japon impérial.
$18\frac{7}{8} \times 12\frac{1}{2}$ (47·9 × 31·7)
E.307–1935

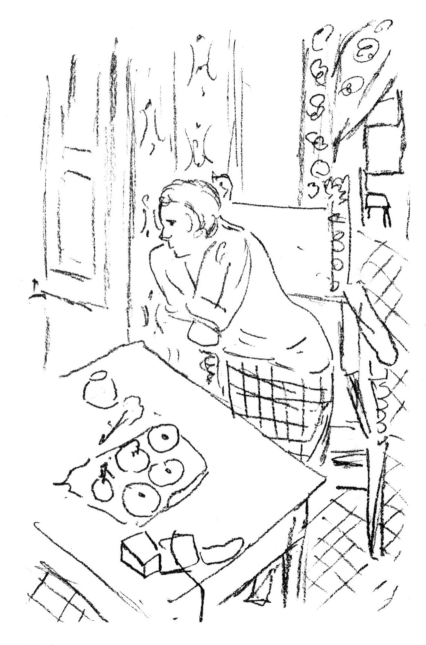

2/50 Henri-Matisse

23 La culotte bayadère. 1925. D. 64

Signed in pencil *Henri-Matisse*. Numbered
2/50
Transfer lithograph on chine. $21\frac{1}{2} \times 17\frac{3}{8}$
$(54\cdot6 \times 44\cdot2)$
E.311–1935

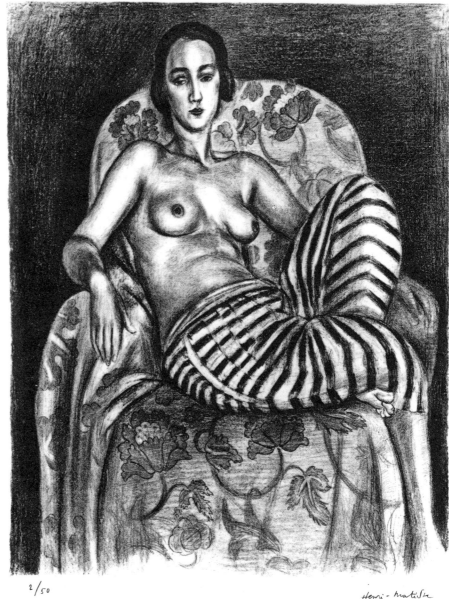

24 Odalisque à la culotte de satin rouge.
1925. D. 66

Signed in pencil *Henri-Matisse*. Numbered
2/50
Lithograph on chine. $7\frac{1}{2} \times 10\frac{1}{2}$ (19 × 26·7)
E.313–1935

Painting of the same subject, but with the
composition in reverse. Present whereabouts
unknown. Reproduced in M. Luzi, *L'opera
di Matisse, dalla rivolta 'fauve' all'intimismo
1904–28*, Milan, 1971, no. 451

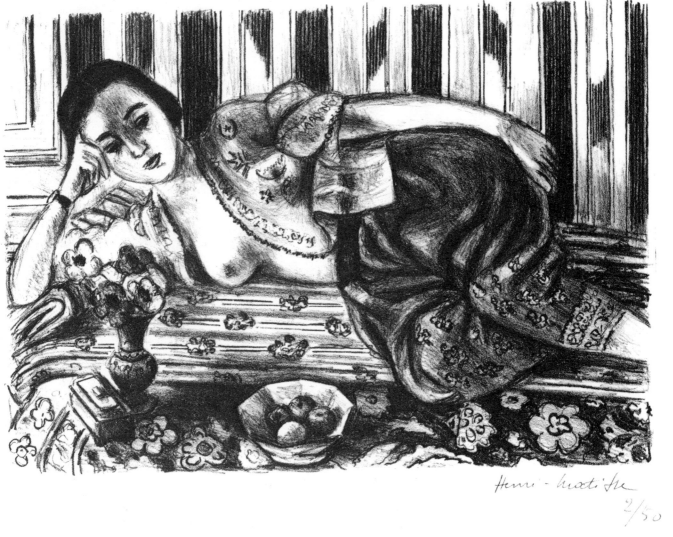

25 Nu assis à la chemise de tulle. 1925.
D. 69

Signed in pencil *Henri-Matisse*. Numbered
2/50
Lithograph on chine. $14\frac{1}{2} \times 11$ ($36\cdot8 \times 27\cdot9$)
E.316–1935

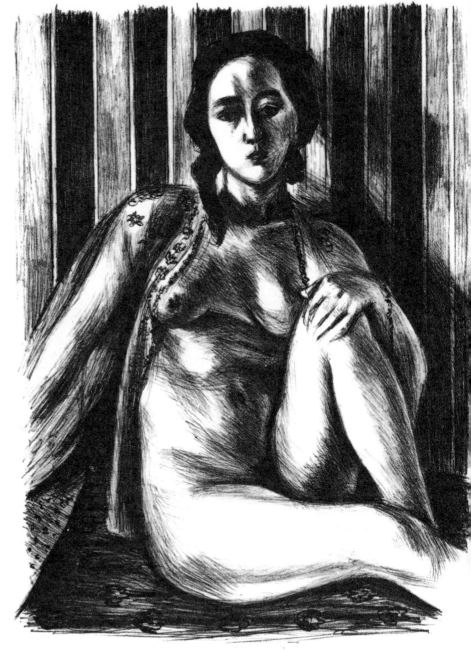

26 Odalisque au visage voilé. 1925. D. 70

Signed in pencil *Henri-Matisse*. Numbered
37/50
Transfer lithograph on japon impérial.
21⅜ × 17⅜ (54·3 × 43·5)
E.317–1935

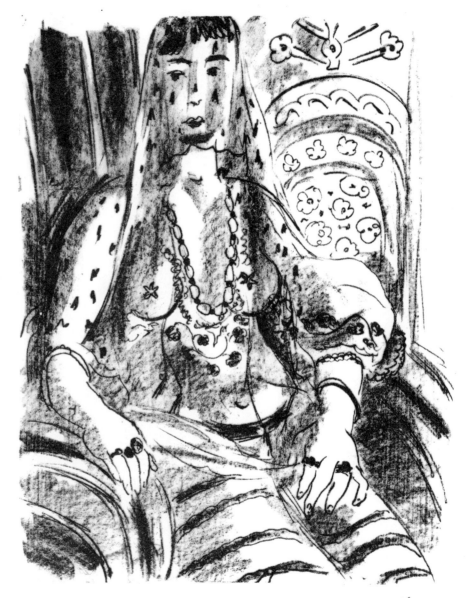

27 Odalisque et coupe de fruits. 1925.
D. 72

Signed in pencil *Henri-Matisse*. Numbered
2/50
Lithograph on chine. $13\frac{1}{8} \times 10\frac{1}{4}$ ($33 \cdot 4 \times 26$)
E.319–1935

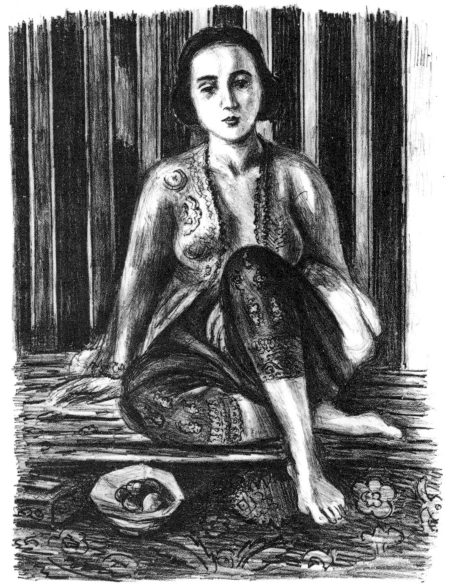

28 Femme au collier. 1925. D. 74

Signed in pencil *Henri-Matisse*. Numbered
2/50
Transfer lithograph on japon impérial.
$20\frac{1}{2} \times 15\frac{5}{8}$ (52 × 39·7)
E.321–1935

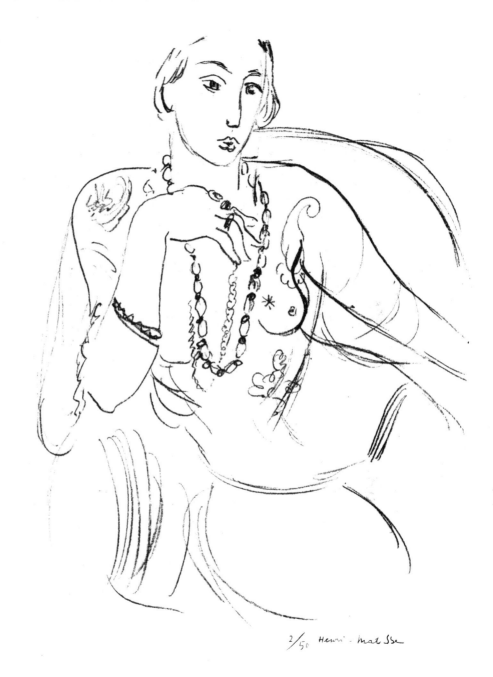

29 Liseuse et bouquet de roses. 1925.
D. 78

Signed in pencil *Henri-Matisse*. Numbered
2/50
Lithograph on chine. $6\frac{3}{8} \times 9\frac{5}{8}$ ($16\cdot2 \times 24\cdot4$)
E.324–1935

Oil painting of the same subject, but with
the composition in reverse, in the collection
of Feigen, Chicago. Reproduced in M. Luzi,
L'opera di Matisse dalla rivolta 'fauve'
all'intimismo 1904–28, Milan, 1971, no. 368

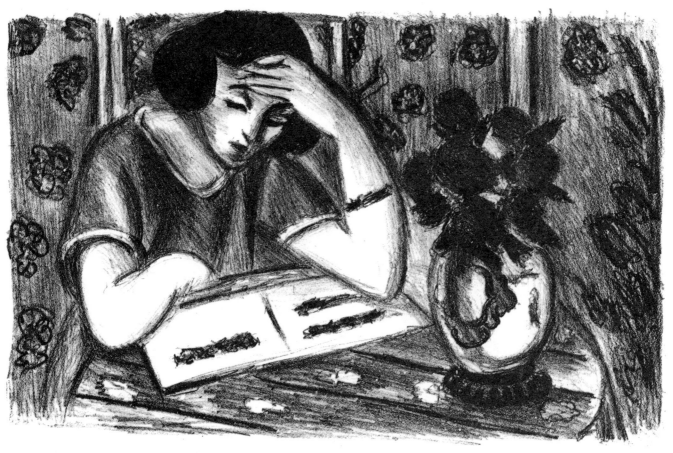

30 Étude de jambes IV (demi-lune).
1925. D. 79

Signed in pencil *Henri-Matisse*. Numbered
2/50
Transfer lithograph on japon impérial.
$11\frac{1}{4} \times 20\frac{3}{4}$ (28·6 × 52·7)
E.325–1935

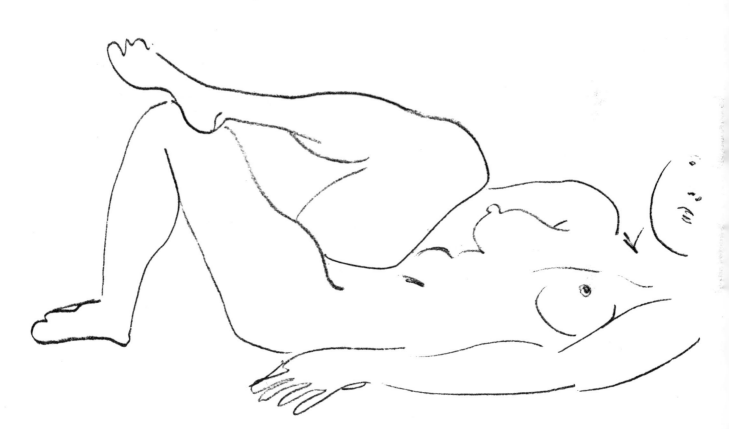

31 Portrait de Cortot. 1926. D. 82

Signed on the stone *HM*. Signed in pencil
Henri-Matisse and inscribed *ép-d'art*
[deleted]. Numbered *2/50*
Transfer lithograph on japon impérial.
15 × 15¼ (38·1 × 38·7)
E.328–1935

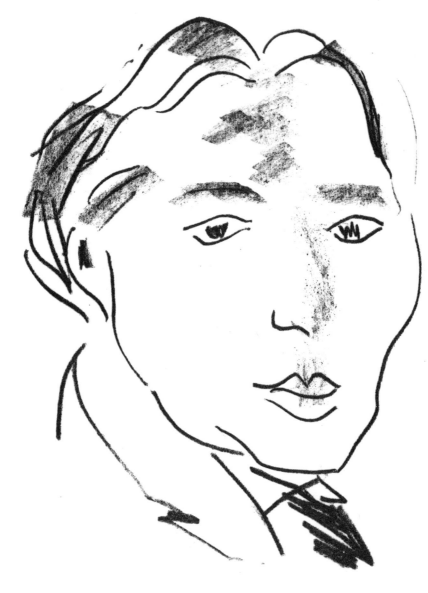

32 Nu, main à l'épaule (Arabesque III). Transfer lithograph on japon impérial.
1926. D. 83 $17\frac{1}{8} \times 21\frac{1}{4}$ (43.5×54)
 E.329–1935
One of a series of 5
Signed in pencil *Henri-Matisse*. Numbered
2/50

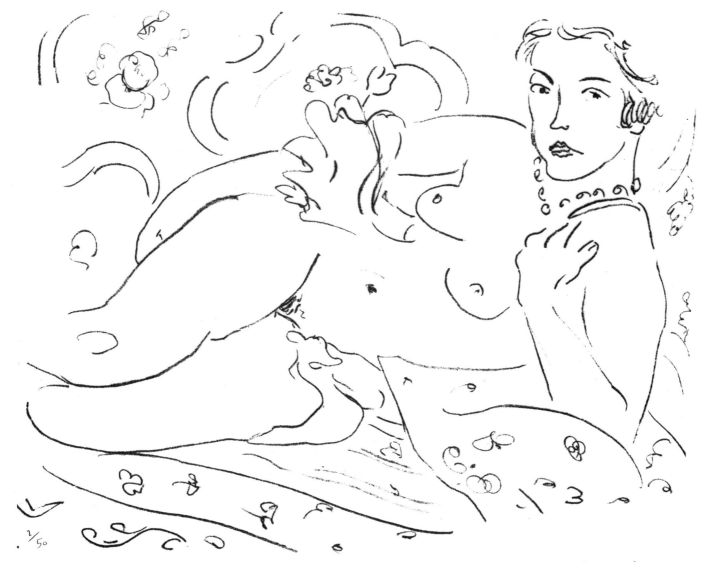

33 Nu couché et coupe de fruits
(Arabesque IV). 1926. D. 84

One of a series of 5
Signed in pencil *Henri-Matisse*. Numbered
5/50

Transfer lithograph on japon impérial.
17¼ × 21¼ (43·8 × 54)
E.330—1935

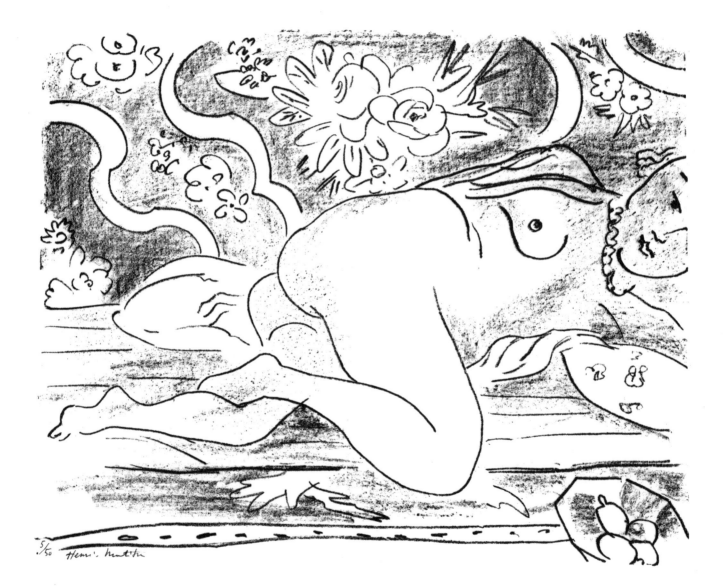

34 Nu, bras gauche sur la tête
(Arabesque V). 1926. D. 85

One of a series of 5
Signed in pencil *Henri-Matisse*. Numbered
2/50

Transfer lithograph on japon impérial.
17¼ × 21 (43·8 × 53·4)
E.331–1935

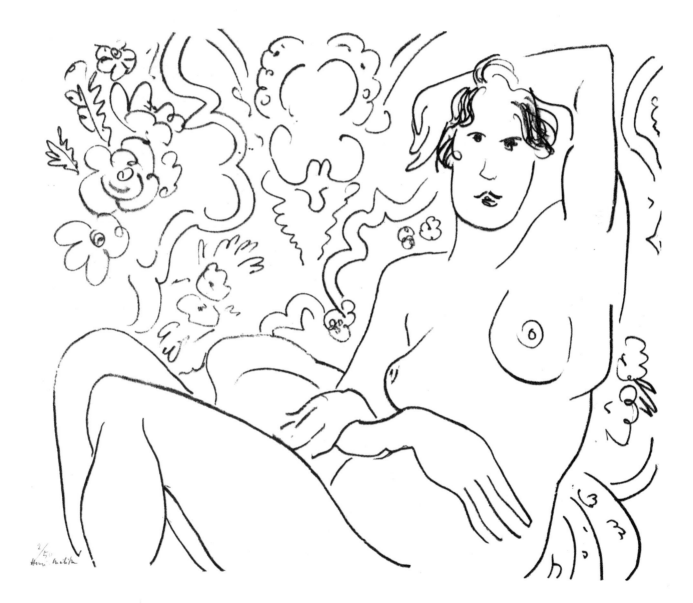

35 Danseuse, reflet dans la glace. 1927.
D. 87

Signed in pencil *Henri-Matisse*. Numbered
2/50
Lithograph on chine. $15\frac{5}{8} \times 10\frac{7}{8}$ ($39 \cdot 7 \times 27 \cdot 6$)
E.1229–1935

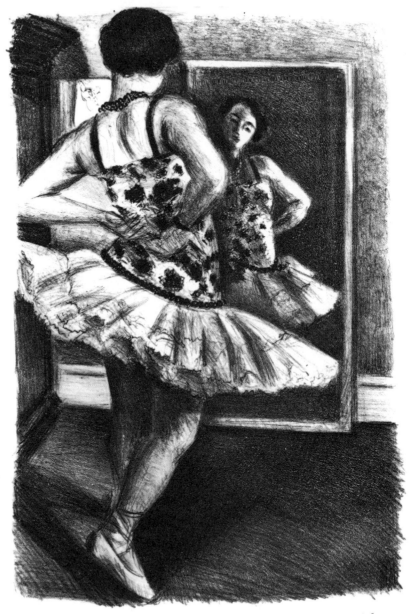

36 Torse à l'aiguière. 1927. D. 88
Signed in pencil *Henri-Matisse*. Numbered
2/50
Lithograph on chine. 14⅜ × 10⅜ (36·5 × 26·3)
E.332–1935

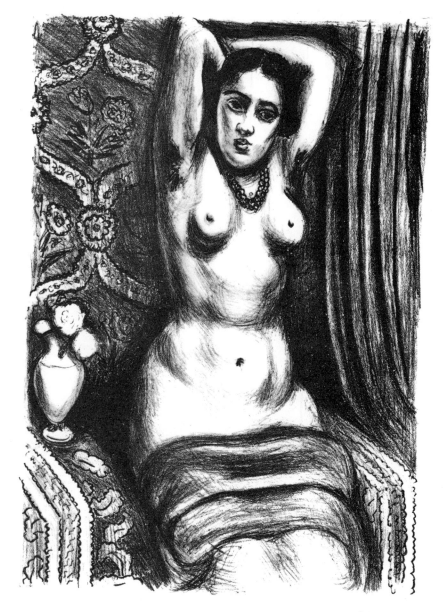

37 Danseuse debout, visage coupé.
1927. D. 101

Signed in pencil *Henri-Matisse*. Numbered
2/50
Lithograph on japon impérial. 17¾ × 10
(45 × 25·4)
E.334–1935

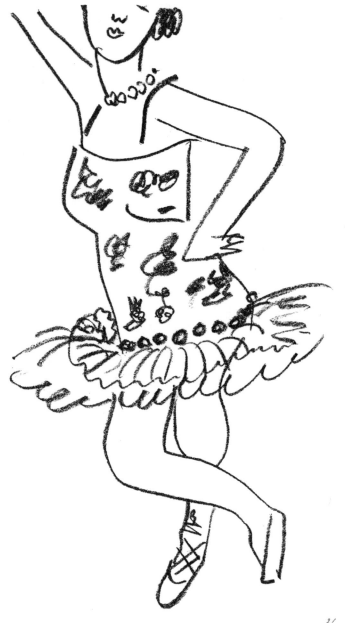

38 Danseuse au miroir. 1927. D. 104

Signed in pencil *Henri-Matisse*. Numbered
2/50
Lithograph on japon impérial. $16\frac{1}{2} \times 10\frac{3}{8}$
$(41 \cdot 9 \times 26 \cdot 3)$
E.337–1935

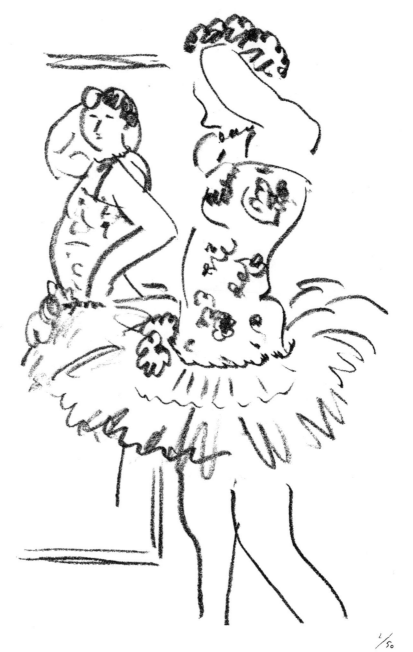

39 Nu au turban. 1929. D. 105

Signed in pencil *Henri-Matisse*. Numbered
6/50
Lithograph on japon impérial. 10½ × 17¾
(26·7 × 45)
E.338–1935

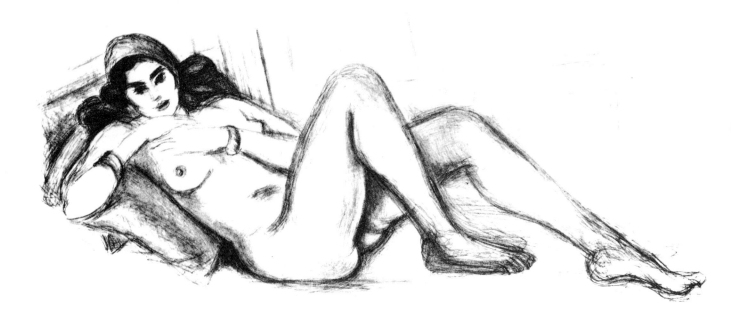

40 Nu assis, bras gauche sur la tête.
1929. D. 108

Signed in pencil *Henri-Matisse*. Numbered
5/50
Transfer lithograph on japon impérial.
16½ × 17⅛ (41·9 × 43·5)
E.341–1935

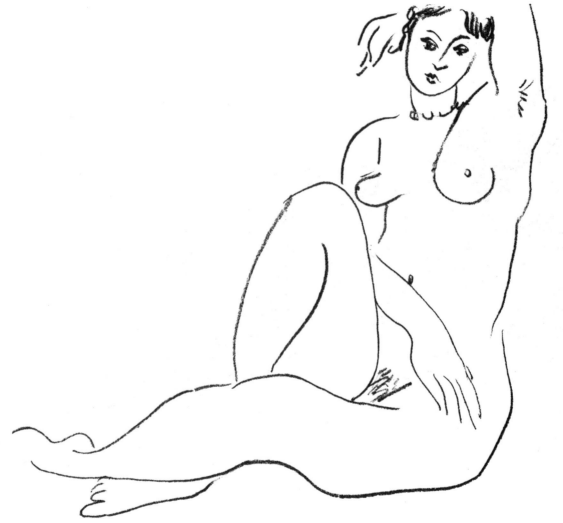

41 Figure endormie, châle sur les jambes.
1929. D. 110

Signed in pencil *Henri-Matisse*. Numbered
2/50
Lithograph on Arches. $10\frac{1}{2} \times 14\frac{7}{8}$ ($26 \cdot 6 \times 37 \cdot 8$)
E.343–1935

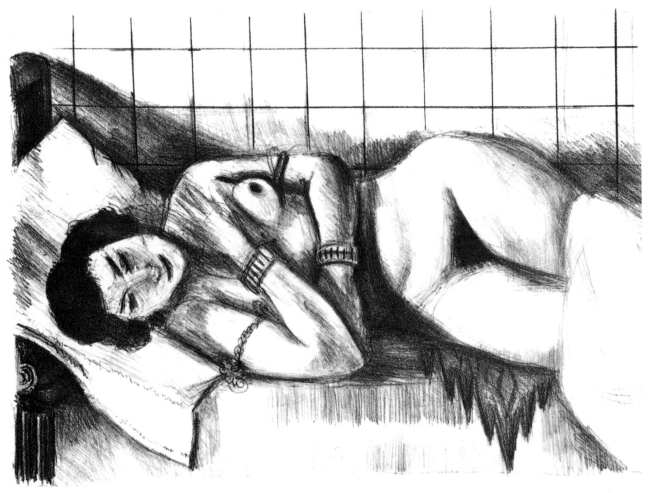

2/50

Henri-Ma

42 Figure endormie (sol aux carreaux
rouges). 1929. D. 112

Signed in pencil *Henri-Matisse.* Numbered
2/50
Lithograph on Arches. 10¼ × 18¾ (26 × 47·6)
E.350–1935

43 Nu couché de dos. 1929. D. 113
Signed in pencil *Henri-Matisse*. Numbered
2/50
Transfer lithograph on Árches. 18⅛ × 22
(46 × 55·9)
E.345–1935

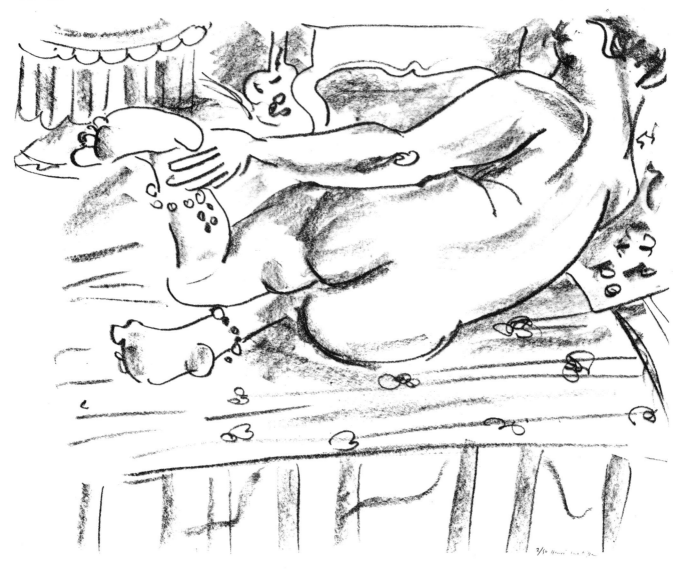

44 Figure voilée aux deux bracelets.
1929. D. 115

Signed in pencil *Henri-Matisse*. Numbered
2/25
Transfer lithograph on japon impérial.
17 × 14½ (43·2 × 36·8)
E.346–1935

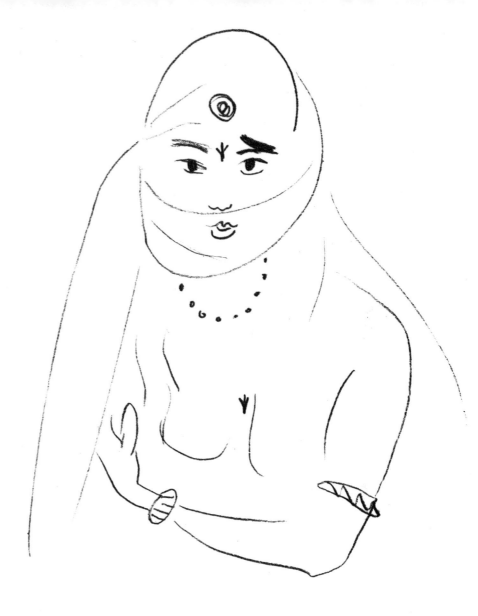

45 Torse nu et collier d'ambre. 1929.
D. 116

Signed in pencil *Henri-Matisse*. Numbered
2/50
Transfer lithograph on Arches. 22 × 17¾
(55·9 × 45·1)
E.347–1935

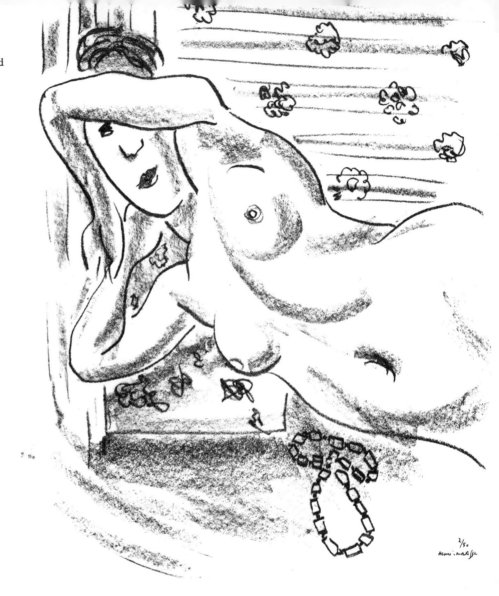

46 Nu renversé et table Louis XV.
1929. D. 118

Signed in pencil *Henri-Matisse*. Numbered
2/50
Transfer lithograph on Arches. 22 × 18⅛
(55·9 × 46)
E.349–1935

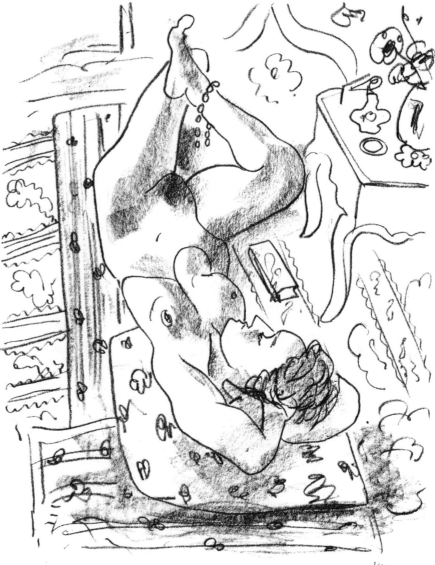

47 Odalisque, brasero et coupe de fruits.
1929. D. 122

Signed in pencil *Henri-Matisse*. Numbered
2/100
Lithograph on Arches. 11 × 14⅞ (28 × 37·8)
E.353–1935

Oil painting of the same subject with the
model's arms in different positions, entitled
Odalisque à la culotte grise, 1927, in a private
collection. Reproduced in colour in R.
Escholier, *Matisse from the life*, London,
1960, opp. p.128

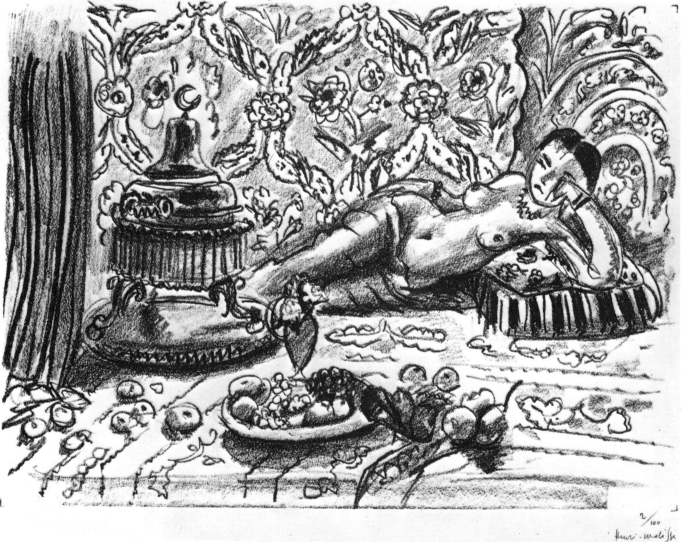

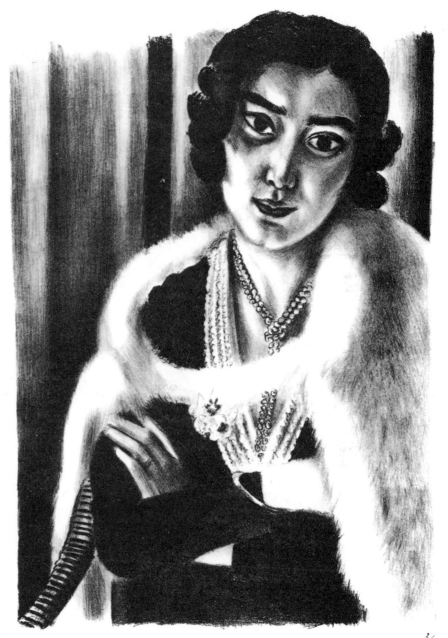

49 Persane. 1930. D. 125

Signed in pencil *Henri-Matisse*. Numbered
22/75
Lithograph on Arches. $18 \times 12\frac{1}{4}$ ($45 \cdot 7 \times 31 \cdot 1$)
E.356–1935
See note to pl. 50.

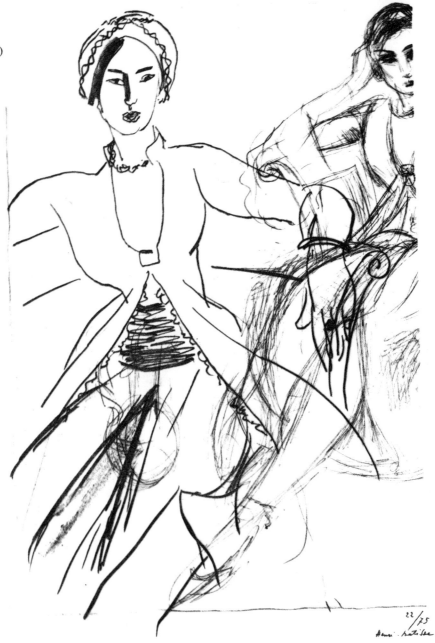

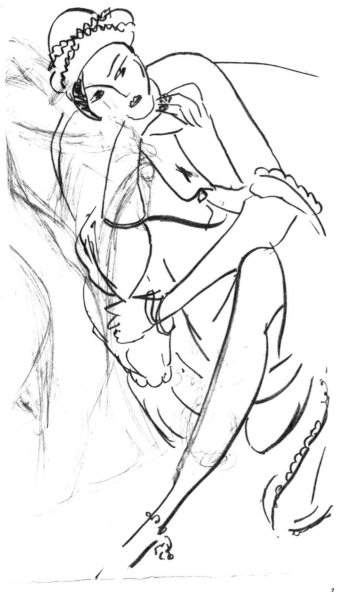

50 Figure dans fauteuil. 1930. D. 124

Signed in pencil *Henri-Matisse*. Numbered
2/10
Lithograph on Arches. 17¼ × 9½ (43·7 × 24·1)
E.355–1935
This lithograph was originally part of the
same composition as *Persane* (pl. 49).
Dissatisfied with the composition, which
has a definite unbalanced dynamism,
Matisse cut the stone in two. An unusually
large edition was printed of the successful
and bigger portion, and a small one of the
rejected part

Published in the United States of America in 1982

Universe Books
381 Park Avenue South, New York, N.Y. 10016

82 83 84 85 / 10 9 8 7 6 5 4 3 2 1

Printed in the United States of America

Library of Congress Cataloging in Publication Data

Lambert, Susan.
Matisse, lithographs.

1. Matisse, Henri, 1869-1954. I. Matisse,
Henri, 1869-1954. II. Title
NE2349.5.M37L36 769.92′4 81-22020
ISBN 0-87663-569-9 AACR2